Painted Ladies

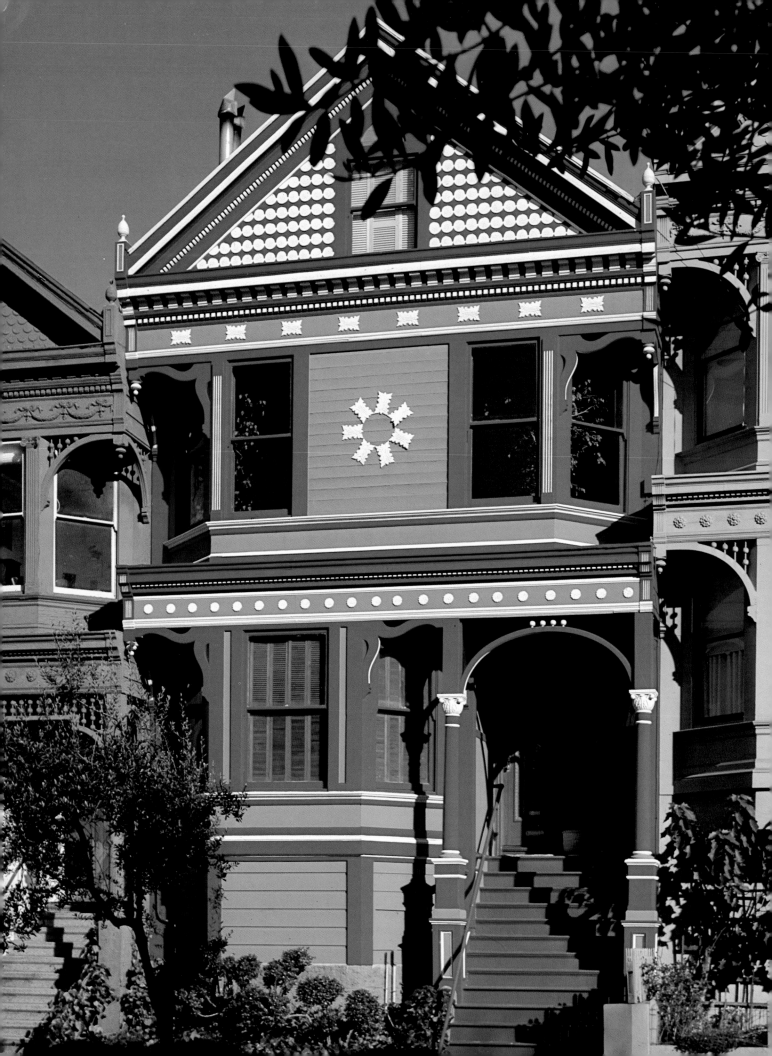

Photographs by
Morley Baer
Text by
Elizabeth Pomada
and
Michael Larsen

PAINTED LADIES

San Francisco's Resplendent Victorians

E. P. Dutton
NEW YORK

Painted Ladies is dedicated with gratitude to the builders,
restorers, painters, colorists, and homeowners who made it possible;
to the legions of the faithful who have fought with words
and actions to save the Victorians; and to the city which gave the
Painted Ladies a setting worthy of their beauty.

(*Frontispiece*). 2650–52 Hyde Street. 1902. Queen Anne row house. 1977. Located a block from the terminal of the Aquatic Park/Ghirardelli Cable Car line, this is the one Painted Lady that can be seen by the thousands of visitors who ride San Francisco's biggest tourist attraction. John Block sketched his house and tried two or three color schemes before deciding to paint the house as you see it here. He's hoping to inspire his neighbors to brighten up their homes as well.

First published, 1978, in the United States by E. P. Dutton, New York. / All rights reserved under International and Pan-American Copyright Conventions. / No part of this book may be reproduced or transmitted in any form or by any means, electronic or mechanical, including photocopy, recording, or any storage and retrieval system now known or to be invented, without permission in writing from the publishers, except by a reviewer who wishes to quote brief passages in connection with a review written for inclusion in a magazine, newspaper, or broadcast. / Published simultaneously in Canada by Fitzhenry & Whiteside Limited, Toronto. / Printed and bound by Dai Nippon Printing Co., Ltd., Tokyo, Japan. Library of Congress Catalog Card Number: 78-59312. / ISBN 0-525-48244-X (DP). 20 19 18 17 16 15 14 13

Contents

Acknowledgments

Our thanks to Tony Canaletich of San Francisco Renaissance; Bob Buckter, Bob Buckter & Friends; Foster Meagher, Color Control; Jazon Wonders, Blissful Painting; Butch Kardum; Alan and Diane Vaughan for their trusty Datsun; Mrs. Bland Platt, one of the creators of *Here Today;* Gary Cray of San Francisco Victoriana; Carol Olwell and Judith Waldhorn, co-authors of *A Gift to the Streets;* Charles Wharton of the San Francisco Water Department; Captain George Jeffrey of the San Francisco Police for being a friend "downtown" as well as a talented novelist; to Cyril I. Nelson, our editor at Dutton, who had to see the houses to become a believer.

As for Morley Baer, even before he thought up the perfect title for this opus, we chose him because we thought his skill, talent, and experience as one of America's foremost architectural photographers made him the best photographer in the world to do this book. We still think so. Publishers will be relieved to know he still has his good right arm.

With his white beard, elfin smile, and well-seasoned irascibility, Morley is a crusty courtly cross between Ernest Hemingway and Edward Steichen, with whom he worked during World War II. He is a wonderful human being, whose strength and character mirrored the buildings, some of which he had photographed a decade earlier for *Here Today.* Morley made photographing the Painted Ladies an inspiring adventure as well as a learning experience.

We also want to thank, in advance, those readers kind enough to make suggestions for future editions of *Painted Ladies.*

Personal thanks to City Cab, under whose auspices I first reconnoitered these lovely ladies; Ray Larsen, angel and toy mogul, and Jerry Larsen, poet and software wizard, for their help and advice; Miriam Viola Larsen, mother, poet, and free spirit, a San Franciscan who never lived here and taught us more than we ever realized or thanked her for; Rita Pomada and the rest of the Pomada and Larsen clans for their encouragement; and last but most to Elizabeth, writer, partner, and TLC giver who even without her blue eye shadow remains my favorite painted lady.

The millennium will be at hand when everyone agrees that beauty and human scale are as important as efficiency in anything designed for human consumption.

By painting Victorian houses with extraordinary attention to details and in every color that hand, mind, and eye can conceive, San Francisco's Colorist Movement is bringing that new age closer house by house.

Why did the Colorist Movement arise in San Francisco?

San Francisco is a unique architectural museum. Its 16,000 redwood Victorians constitute one of the world's architectural treasures. Brilliant sunshine and crystal clarity are the natural medium of this hill-filled, fog-washed Baghdad-by-the-Bay. The warmth of these houses reflects as it enhances the city's great natural beauty.

Drugs, media, and the counterculture have made this an age of color. A revulsion against the sterile, inhuman, intimidating monoliths spreading like architectural ooze over the downtown landscape helped foster the need for the enduring stability and character of the Victorians.

San Francisco is a haven for people who can appreciate as well as create Painted Ladies. To people feeling increasingly like helpless victims of big corporations, big government, and jobs which are means not ends, painting their homes is a satisfying form of self-expression. Nothing in San Francisco has been as effective in making people take pride in their homes, streets, neighborhoods, and city as paint applied with imagination. (And if that gives the bureaucrats any ideas on urban renewal and increasing unemployment, so be it!)

The Colorist Movement developed spontaneously but haltingly in the 1960s. Isolated beacons of color painted by a few courageous souls cropped up and immediately aroused the ire Painted Ladies still do on the grounds of tradition and aesthetics. Nevertheless, the momentum of the movement accelerates, spurred by the creative tension of beauty and money.

Thanks to the passion and creativity of painters, colorists, and homeowners, the Painted Ladies will not only survive the evils of modernization but are now more beautiful than ever. Tradition is not only preserved but enriched with a fresh eye and bright coat of paint. The Painted Ladies are exquisite examples of how an American tradition worth preserving can be revitalized and made meaningful to a new generation. Because they are a breathtakingly beautiful lesson in renewing a tradition and a city, they have additional significance for this and future generations.

Yet even these dazzling damsels cannot be taken for granted. San Francisco has not been granted immunity from the inevitable earthquake or from the same melancholy litany of cities across America: minority unemployment which leads to crime which leads to the exodus of middle-class families. To which one must add a recent prediction that we shall be the last or next-to-last generation able to afford a house of our own.

The right of these Victorians to exist must also be balanced against the need for adequate housing for all income levels, a reality which the success of the Colorist Movement has paradoxically made more difficult to achieve by rapidly escalating the cost of a house.

Seeing Is Believing

The conductor George Szell once said that listening to music on a phonograph is like getting kissed over the telephone. So while posterity will be fortunate to have photographs as beautiful as Morley Baer's to immortalize the Painted Ladies, you must see them really to appreciate them.

Nothing can match the experience of encountering three stories of bright colors against a clear blue San Francisco sky. And few urban delights equal wandering around the town's Painted Ladies on a sunny day. If you are still wondering what makes San Francisco so special, all you have to do is go look.

The combined effect of color and scale is, like inhaling pure oxygen, irresistibly exhilarating. To come upon one of these houses unexpectedly is to experience a sudden rush of pleasure.

As you stroll along a street like Fair Oaks in the Mission District, your eyes develop greater sensitivity to felicities of color and design. You sense how one house being painted led to another, creating an endless series of gems in the variegated necklace of Victorian San Francisco.

But don't wait. Colors fade. The same need for protection and artistic expression which inspired homeowners to paint these Victorians will inspire them again. By the time you see these houses, some will be repainted. The house at 2540–44 Sutter on page 36 was repainted before we even finished shooting! *Painted Ladies* only captures a moment in time—the class of '78.

Painted Ladies is a collection of the best houses, details, and rows of houses our unscientific search uncovered. The aim in selecting was that each house be unique in color and architecture. Some are stronger on color, others on architecture, but most are a happy marriage of both.

However, we only scratched the surface. Telephone poles and wires; fire escapes; trees, traffic; construction equipment; shadows of other houses; the season; insufficient light; similarity to a finer example of the same color scheme or architecture; weathered paint; ground-floor businesses; the economic need to limit *Painted Ladies* to a small book illustrated entirely in color—all conspired to prevent us from photographing many more.

In preparing this book, it became apparent that we were producing another in a line of historical documents. We hope that *Painted Ladies* is worthy of joining such company.

We also hope that the end of *Painted Ladies* will be a beginning for you. For us, this book will be successful only if it coaxes you into seeing the houses for yourself (the photographs are arranged with that in mind) and starting your own collection of Painted Ladies—and if you own a house, into letting your artistic instincts take flight to create a Painted Lady of your own. Welcome to the Movement!

M. L.

"We have from time to time called attention to the crazy style of architecture adopted by a few of our younger would-be architects. One of the principal ingredients of this style is to cover the buildings, when finished, with a bountiful supply of paint, using more colors by far than the tailor who designed Joseph's Coat. . . . Red, yellow, chocolate, orange, everything that is loud is in fashion, and the entire exterior is so gay that a Virginia creeper or a wisteria would be bold, indeed, if it dare set leaf or tendril there. If the upper stories are not of red or blue . . . they are painted up into uncouth panels of yellow and brown, while gables and dormers are adorned not with tasteful and picturesque designs, but with monotonous sunbursts and flaming fans done in loud tints. It is easy to be odd, easy to be more odd, than the oddest thing yet done . . . "

Since the early 1970s, San Francisco's Victorian houses have been shining forth in blazing colors, but the above quote is not a recent editorial from the *San Francisco Chronicle*. It ran in *California Architects and Builders News*—in April 1885. Though purists have deplored the appearance of Painted Ladies and fans have delighted in these islands of color, there is nothing new under the sun.

True, San Francisco has, until recently, been pictured as a pastel town in danger of being permanently grayed over by creeping monoliths. But we should remember that the Greeks painted the Parthenon in colors bright enough to make Zeus blink. The Mayans, Romans, Egyptians, and Etruscans all decorated their homes and public buildings—inside and out—with vivid mosaics and designs in marble and paint. We don't have to look back centuries to find gaudy buildings. San Francisco was a gaily bedecked town from its first architectural flowering.

When we started work on this book, we thought we had uncovered a new folk art, a new wave of painting houses in brilliant colors that was just another example of how the people of San Francisco were starting a new trend. It turned out that exuberant Victorians beat us by a century.

Almost overnight, San Francisco exploded from a sleepy port to a thriving city sprinkled with gold dust. Ornate palaces and row houses mushroomed along new streets. Some people simply ordered prefabricated homes piecemeal. Others started with careful plans, using architects or buying the plans that were available by mail at the time. And still others created small but comfortable homes out of leftovers from the castles of the kings of commerce on Nob Hill.

False fronts, or parapets, covered with gingerbread made even little box-frame houses look impressive.

Some 48,000 Victorian houses were built in San Francisco during the 65 years between the Gold Rush and the Panama Pacific International Exposition in 1915. Nearly all the sumptuous palaces on Nob and Rincon Hills were destroyed by the 1906 earthquake and fire. The smaller mansions, town houses, row houses, and mass-produced Victorians that remained, in sections west and south of the burned-out downtown area, survived.

During the two World Wars the Victorians lost their wrought-iron crests and ornamentation and gained a coat of Navy surplus paint—battleship gray. Misguided modernization has smothered almost half of the remaining 16,000 homes (28 square blocks in the Western Addition were bulldozed in the 1950s and 1960s) by covering up their Victorian charms with stucco, asbestos, tarpaper, brick, permastone, aluminum siding, and textcoat. San Francisco is still the largest city in the world whose buildings are predominantly Victorian in character. This heritage is slowly being restored to its former glory.

For half a century the Victorian homes of San Francisco were respected because of their age and style—and because they had endured the 1906 earthquake. But the facades crumbled with age. The powder cracked, the mascara ran. Stucco salesmen during the 1920s offered a discount to homeowners who could persuade their neighbors to stucco their Victorians. Thirty years later, Johns-Manville Company salesmen talked thousands into covering their fading beauties with asbestos shingles. The asbestos was supposed to protect the homes from fire and reduce maintenance costs. It sheared the Victorians of all detail and character and wasn't even fireproof.

Then, in the psychedelic sixties, a few hardy souls had the courage to paint their homes in the colors of the day. To an outcry that they were barbarians, San Francisco's Painted Ladies slowly, almost shyly, showed their new finery. The gingerbread facades that were scornfully likened in an editorial of the 1880s to the "puffing, paint and powder of our female friends" were given new life with fresh cosmetics that changed the city's complexion. By the mid-1970s, San Francisco's Victorians were appreciated once again.

In 1976, Herb Caen, the town's gossip laureate, noted a Little Old Lady who'd been watching two painters at work on a Victorian on Page Street. On the fourth day, as they were applying a fourth color, she yelled up: "Now you boys stop dropping acid—you've got enough colors up there already!"

At one point, the coloring craze was such that Francis Ford Coppola's *City* magazine sponsored San Francisco's first Victorian Coloring Contest. Readers could use crayons, paints, and Magic Markers to decorate four houses printed in black and white. Alas, the magazine folded before the winning entries could be published.

What had started as a lark, as a new way of looking at old houses, became a solid trend, with serious historians helping to resurrect what had long been ignored. Neighborhoods on their last legs and homes scheduled for demolition were painted, prettied up, and revived. San Francisco had discovered yet another way to lead the country into the future—this time by rediscovering its past.

From Village to Victorian Metropolis

A *New York Times* writer who visited San Francisco in 1883 wrote: "Nobody seems to think of building a sober house. Of all the efflorescent, floriated bulbousness and flamboyant craziness that ever decorated a city, I think San Francisco may carry off the prize. And yet, such is the glittering and metallic brightness of the air, when it is not surcharged with fog, that I am not sure but this riotous run of architectural fancy is just what the city needs to redeem its otherwise hard nakedness."

One hundred thousand people moved into San Francisco in the twenty years between the discovery of gold at Sutter's Mill and the completion of the Central Pacific Railroad in 1869. During the Gold Rush, people threw up tents and log cabins made of mud and lumber from the ships stranded in the harbor. One enterprising homeowner built his cabin on Jackson Street on a foundation of large boxes of Virginia tobacco because they were handy. Later, when the market price of tobacco made the foundation more valuable than the building, he tore it down, to sell the tobacco. And what did he put up in its place?

The buildings rising in San Francisco in the 1860s, 1870s, and 1880s were as eclectic as the people living in them, who came from every corner of the world. Carpenter Gothics, French Renaissance palaces, Turkish towers, stately Italianates, accented Sticks, embellished Eastlakes, and regal Queen Annes advanced triumphantly up and down every hill.

A growing middle class, a fast-developing industrial technology, and a flourishing economy were responsible for the rapid growth of the city. Money heightened the desire for opulence. Scrolls, fretwork, fans, cut and beveled glass, pediments, cornices, balusters, and designs of lionheads, rosettes, and vines were piled on top of each other. The new iron steam press and gang and scroll jigsaws made it possible to bend, curve, shape, and stamp wood into any desired form, and cheaply. Mass housing was both possible and profitable.

Mendocino's redwood provided the perfect medium. Handy, durable, economical, and extremely strong, it had a clear open grain that did not splinter when nailed and was soft and easy to cut in the sensuous shapes in demand.

The new "Victorian styles" freed living plans from the rigid symmetry of Colonial New England and Southern plantation architecture. This new freedom also allowed for towers, balconies, and rooms of all shapes arranged purely according to the owner's whims.

The jaunty lines of comfortable one- and two-story houses with festooned fronts and jutting bay windows provided efficient, well-lighted, sanitary shelter to the growing majority of lower- and middle-income families who had usually been ignored by architects. The styles were equally suited to rich and poor and also had the necessary advantage of not demanding too much skill from their architect or builder.

For all their ruffles and flourishes, Victorian row houses maintained an appearance of airy lightness, because their distinguishing feature was not their cheapness or mélange of architectural styles: it was the bay window. From the 1860s to the 1890s, homes became more elaborate, reflecting the city's increasing affluence and stability. The bay window gradually became the principal structural element until entire street fronts seemed to look like faceted walls of glass and color.

In a city of 25-foot-wide lots, the row houses had to forgo side yards and some side windows. The bay was adapted to increase light inside the house. Because it admirably filled those demands of light, convenience, space, and healthiness, every existing architectural style in San Francisco was altered to accommodate it. In the 1870s, most bays on Italianate buildings were constructed with slanted sides on the windows. In the 1880s, Stick/Eastlakes became more popular, with square-sided bays. After that, bays were variously slanted, rounded, or arced, and always lavish with intricate carvings.

In San Francisco, Victorian architecture is a catchall phrase identifying a variety of styles and approaches used in the second half of the 19th century and up until 1915.

There are three basic "Victorian" styles in San Francisco: Italianate, Stick or Stick/Eastlake, and Queen Anne. Less common styles are the early Carpenter Gothics, with pointed arches and wood painted to look like stone, and Victorian Gothics that had hood molds, moldings over the windows, and rich decorations under the gabled eave. Tudor homes have flattened squared arches; Gothic Revival houses have high-pitched roof lines with simply trimmed gables. The three French Revival "petit palaces" in San Fran-

cisco are noted for their baroque embellishments and oval windows. (The house at 1347 McAllister, seen on page 45, is one of these three.)

Italianate architecture uses forms and adornment derived from 15th- and 16th-century Italian palace architecture. Most Italianates have a straight vertical look, with tall narrow doors and windows (the better to fit into those 25-foot lots!), elaborate squeezed pediments, and Corinthian columns on the porches. Flat roof lines are sometimes concealed by decorative false fronts. At first, many Italianates were painted to look like stone.

Stick style might also be called Strip style, because it is named for the use of wooden sticks or strips to outline the square bay windows, doors, and framework of the house. On a Stick house, the wood is frankly treated like wood. The house is tall and narrow, but built with a lighter frame than the Italianate and reinforced by nailed-on sides. This siding is then accented with paint, defining the outlines of the house. The addition of gingerbread millwork on the facade resulted in a new style: *Stick/Eastlake.* (See the Mish House, 1153 Oak Street, on page 54.)

Poor Charles Eastlake! In his treatise, *Hints on Household Taste,* he called for simple, tall, slender, graceful furniture, with every piece performing a function. San Franciscans did exactly the opposite with their houses—piling gingerbread on top of treacle, flowery forms on top of fruit salad—and named the resulting hybrid after him. The Eastlake style was popular because it could easily be copied by any carpenter who could order from a catalogue or follow a mail-order pattern. Such a straight, easily built frame house could then be made special with the addition of machine-carved trappings. Several thousand such homes were built at low cost under long-term financing, with the blessings of the Real Estate Association of San Francisco.

In 1877, *American Architect* magazine defined the *Queen Anne* style as "any eccentricity in general design that one can suppose would have occurred to designers 150–200 years ago." In San Francisco, it means a house with a steep gabled roof, shingled walls or panels for added texture, a rounded turret corner tower or two, and a front porch usually inside the main structural frame. (The house at 1348 South Van Ness, on page 73, is an excellent example.) Queen Anne row houses still have a sharp gabled roof and a curve to the porch line, but they don't have "witches' hats." Gradually, an intricate design combination of Italianate, Stick, Eastlake, and Queen Anne forms became known as San Francisco style.

Photographing the Painted Ladies in constantly changing, highly contrasting light and shadow brought home the truth that San Francisco's bay-window Stick style represents, as Henry Kirker put it in *California's Architectural Frontier,* "A rare example of architectural transformation as the result of regional environmental conditions: The character of Stick architecture depends upon shadows thrown across the surface by projecting structural members. San Francisco, with its continually attenuating fog and sunshine, is a city of strong contrast; the light is flooding and the shadows deep . . . it was the distinction of the San Francisco rowhouse, to which this style is most frequently applied, that no structural member was denied the privilege of projection . . . a genuinely regional juxtaposition that gave the California frontier its only significant urban architecture."

Color in an Earlier Age

"For a long time, the public mind seemed powerless to conceive of anything more sublime than the conventional bay windowed house . . . just when the present esthetic movement began, it would be hard to determine; but it first manifested itself in a growing aversion to gray paint. Cautiously at first, then more and more boldly, houses appeared in browns, yellows, greens and even reds—all sorts of unorthodox colors; yet one was forced to admit that the town did look better for it." (*San Francisco Chronicle,* June 19, 1887.)

The Gold Rush frame houses, many imported in pieces from New England, were painted white and fitted with green shutters. Soon some had peaked roofs trimmed under the eaves with Gothic drippings and millwork. Stained-glass windows and Oriental rugs vied with an abundance of greenery to spark the somber Victorian shades. But many houses were painted not in white or gray hues but in two, three, or more colors—the brightest colors available at the time. And although the Victorians many San Franciscans remember were painted in pastels and earth tones—light tones held up best over the years—architect John Pelton and his colleagues rebelled against "leaden hues draped in sable fringes," and painted their houses green, yellow, peach, sage, Indian red, and vermilion.

Row houses were terra cotta, mustard, brown, and olive-green. An architect of the time wrote: "A successful painter (H. A. Downing) once said to use . . . the colors of the ground or the colors of different natural stones . . . we have also painted several buildings in the picturesque style, in the following colors: body, maroon; trimmings, seal brown; sash, ash yellow; roof, dark brown; base, dark Indian red; doors and vestibules in oak . . . [another] base, Pompeii red; body, olive green; trimmings on body, bronze green; underneath cornice, terra cotta; roof, Venetian red and black; front doors, side doors and vestibules in grain mahogany." (*Picturesque California Homes,* 1885)

Painters in the last half of the last century used different colors to point out the different parts of the

house. Some homes looked as if they had been painted in stripes: the ground floor would be one color; the second story another; trim, another; roof, another; and so on.

In 1878, an article in *Modern Dwellings* advised, "Upon any portion of the house receding from the facade, such as an alcoved balcony or recessed door-way, when deeply sunken, positive colors would be in keeping . . . when an exterior is of neutral buff, the sides of a deep window recess are painted a deep ultramarine green; the trimmings of Indian red are relieved by lines of black, and the coved ceiling is of brilliant blues."

Exterior Decoration, a Treatise on the Artistic

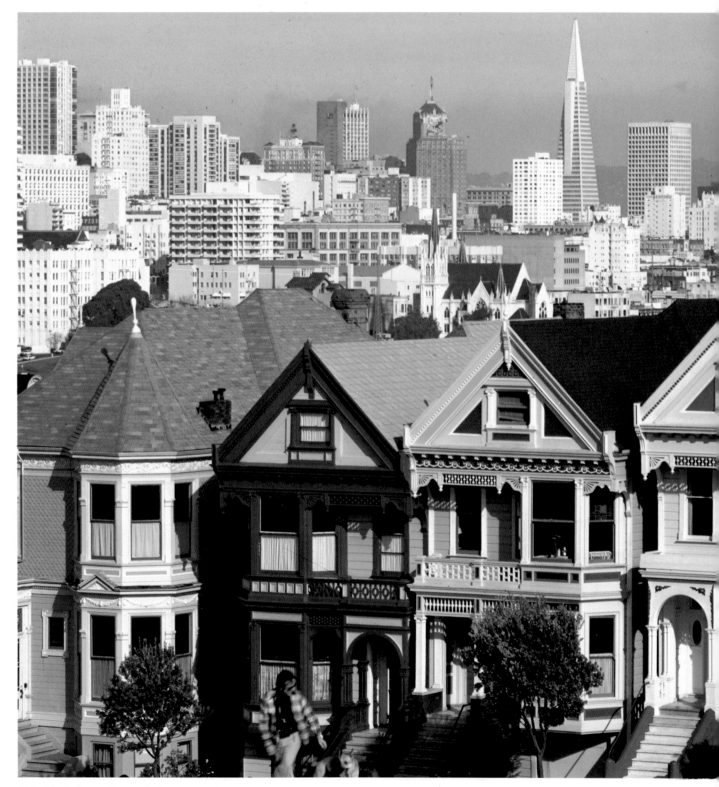

712–22 Steiner. One of the most photographed streets in San Francisco, this group of Queen Anne row houses was built in 1894–95 by contractor Matthew Kavanaugh.

Use of Colors in the Ornamentation of Buildings presents a series of designs illustrating the effects of different combinations of colors on various styles of architecture. It even provided paint chips for color samples. One house was shown with three different choices of seven colors each to go with the different parts of the house.

Although the style of painting houses has changed from painting in stripes or filling in the parts of the house with different colors, San Francisco is still undergoing a gradual metamorphosis from whites to grays to olives and browns, moving on to a new breed of designing colorists who use at least four (and up to eleven) deep, crisp, contemporary colors. And while the rich are conservative in taste and lean to-

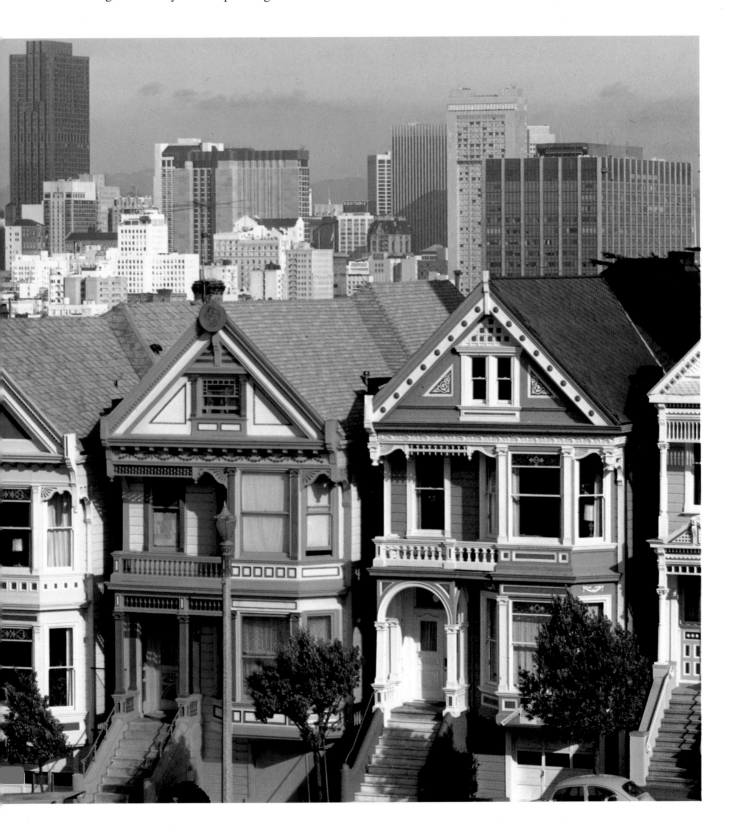

ward painting their homes in neutral tints—just as they did a century ago—Painted Ladies are being primped across the city, from the poshest to the poorest neighborhoods.

Laborers of Love

Butch Kardum views painting his house as a means of expression. "There are so few ways you can do something that's uniquely yours." In 1963, when he first experimented with juxtaposing intense blues and greens on his own Italianate home, the reaction ranged from rage to adulation. Then he noticed that other people on the block started to clean up their homes and repaint, either decoratively or not, until the whole block was renewed. He realized that decorative house painting could serve to get others inspired in the movement of loving, living in, and saving old houses.

Kardum is a neighborhood activist, working to help the city by painting houses glowingly, planting trees to show permanence, and making a physical contribution to maintaining and enlivening San Francisco's architectural tradition.

One of his first experiments was a big gray apartment building near Alta Plaza Park. He painted it "brassy" on purpose. "I thought if people could pick up on the fact that one person can fix up a house, save it from the wrecker's ball, they would save it and others. The houses in the Western Addition were second rate housing being torn down by the carload. People were just really asleep. They couldn't see the buildings. They would miss all the ornamentation—especially on the bigger buildings that were just so many large drab areas. Many houses in that neighborhood were saved from extinction by on-site restoration or by moving them to other locations (1737 Webster, on page 24, was moved to its present lot). Now, restoring and preserving Victorians is even economically profitable."

A painter as well as a color designer, Kardum first interviews a prospective client to decide whether the house will be done in light, medium, or dark colors. Then he puts a primer on and puts a color sample of all the colors he plans to use in a small area so the owner can see the juxtaposition of the colors. Because he feels that many people can't express in words what they really want, he takes the time to talk to them, and tries to help them express their ideas. He takes into allowance the architecture and the neighborhood, so the building won't stick out like a sore thumb. If it's grand architecture, he says, he won't take too many liberties.

Butch Kardum's sign is also being put up outside of San Francisco. He has provided color schemes for houses in Rochester, Minnesota, and Seattle, Washington. He revitalized the Steinbeck House, a restored museum/restaurant in Salinas, California. Research showed that the house was originally dark green with earth tones on other areas and red trim. The ladies of the John Steinbeck Society didn't want that. Nor did they want the ubiquitous white with green shutters. So Kardum refurbished the Queen Anne/Eastlake mansion to make it fit right into the decor of *East of Eden* by using buff, putty beige, tobacco brown, and bright Delft blue.

The owner of the Monterey Jack House, the largest Victorian mansion in Salinas, across the street from the Steinbeck House, so admired Butch Kardum's work that she hired a friend of hers to "outdo" it. And for this colorful lady, colorist Tony Canaletich prescribed six lively colors.

Tony Canaletich was the color consultant for Bob Buckter & Friends as well as for other painters. An art major in college, Canaletich knew when he started painting in 1971 that he didn't want to work indoors, so he began haunting paint stores to ask contractors if they needed help. Impelled to experiment with as many colors as he could get away with, he has found designing for real estate speculators a two-edged proposition: although they have the houses painted to increase their values (without paying painters a commensurate percentage) Canaletich is allowed to choose the colors he wants.

Canaletich treats large areas inconspicuously, then emphasizes special areas and architectural adornment with bright colors. He feels that in this age of color—color TV, bright clothing, posters and record albums—houses, too, should be radiant.

To find out what will please his clients, Canaletich "psychs them out." Half of his clients give him a free hand. He mixes his colors by hand. (His traveling palette is 100 quarts of paint in his van.) He prepares a quart for "swatch" purposes and has the paint store match it. (As long as the sample is wet, the store can make a perfect match. Some types of pigment such as deep browns and maroons darken by 15 percent after drying.) Then, like Butch Kardum, he paints a section of the house (perhaps a corner near the bay window) using all of the colors together, so his customers can visualize the result.

Canaletich thinks that colors make a psychological statement about a person. Color can reflect character, philosophy, sentiments, even political leanings. When a Haight-Ashbury couple returned from Tibet and commissioned Canaletich to design their house, they requested that it look like a Tibetan monastery. It was painted in ten colors of the Tibetan mandala—from gold and cream to burgundy and navy—and decorated with "om" signs and smiling cherubs.

Canaletich has worked hard to show people that different, brighter hues can be used with good taste. For a long time, he says, he had to "sneak in the third or fourth color to convince people that the neighbors

wouldn't hate them or think they're strange."

Bob Buckter said that the most resistance he encountered was from architects "because they traditionally like the trim to accent itself by means of shadows." Buckter and Canaletich faced their biggest challenge in 1975 in the Mish House (page 54). The architect involved wanted gray and maroon. But Canaletich and Buckter insisted, "We choose the colors or we don't do it." They came up with a dazzling but tasteful combination of navy blue, pale yellow, gold, silver, maroon, saddle brown, gold gilt, and light blue. It is an important, imposing house on a heavily used street, and Bob Buckter & Friends put everything they had into it, spending twice as long as they had been paid for, to make every detail perfect.

Today, one of the proudest possessions of over 200 homeowners in San Francisco—next to their Painted Ladies—is the Bob Buckter & Friends sign, embellished with a hand-painted miniature of the house itself.

Canaletich is gratified that the Colorist Movement has flourished as it has. "People have seen what can be done with old houses, can see the craftsmanship and wood ornamentation that could never be duplicated today." Now, even people who have newer stucco buildings are turning to paint to give their homes new life.

Jazon Wonders of Blissful Painting has also become involved in using multicolors and graphics on stucco. But his real love is giving new zest to Victorians. He feels that colors can control people's emotions, can make houses cheerful, and bring joy to the streets. He uses clear, vivid colors and "brings a little bit of the countryside into the city so it's not so gray and depressing."

In 1972, when he painted his first multicolor in lavenders, the neighbors complained so bitterly that Blissful Painting had to tone it down with whites. To compensate for their double work, the owner let them "go to town" on the house behind the first one; and the painters went wild, using violet, lilac, and silver.

Wonders meets with his clients, does a sketch of the building, and suggests colors. Half the time, his clients have preconceived ideas, but Wonders can usually persuade them to use more colors than they had considered. One man who asked Wonders to paint the Stick-style Victorian his grandfather had built in the 1880s had three colors in mind. Wonders countered with five others that "looked like neon" to the client, who has become proud of the effect since strangers started to inquire about the house.

Blissful Painting did a stately Stick/Eastlake home (1451–53 McAllister, page 44) with gold and blue, as the owner had asked. When the work was finished, the lady next door who'd been saving her money for years to paint the house asked him to do her house (1463–65 McAllister, page 47) in greens. The house, with its carefully detailed cherubs (cheerfully given a third blue eye by Wonders), is now the female half of one of the most widely admired and recognized male/female Stick/Eastlake pairs of Victorians in the city.

Wonders has designed homes in Pismo Beach, Healdsburg, and the Gold Country, but he most enjoys working on undesirable properties or in declining neighborhoods—because he can rejoice in the neighborhood renovation. His work is so delectable that M & M's, the candy manufacturer, used it for a television commercial.

Foster Meagher of Color Control says: "It only takes one good flower to make everyone want to fancy up." After six years of serving as a color consultant for small private homes, businesses, and government-backed projects, Meagher is rightfully proud of the effect his work has had on neighborhoods. "Gardening tools appear, the street gets swept, windows are cleaned. The people in the neighborhood don't change, but now they have something to be proud of, to respect, and none of the newly painted Victorians ever gets graffiti or abuse after they are finished."

Meagher feels he has a different approach to painting Victorians. He takes an architectural approach and makes the color perform as an entity. He considers five elements in applying color:

Body color, or predominant tone;
Architectural color;
One or two "punch" colors;
A shadow value, to make unseemly or overly large dull space recede;
A light color to bring something attractive to the fore.

For example, in the Queen Anne at 1348 South Van Ness (page 73), a doctor who wanted to raise his patients' spirits asked Meagher to do something playful, yet dignified. He used a brown tone for the body, burnt umber on the base, yellow as the punch color—it's the one we remember when we think of the house—and a glossy white as the architectural color. In other words, the building would remain standing if only the white parts, the columns, and corbels (brackets holding up the windows and roof) were there.

Meagher specializes in color design. After studying a house throughout the day and researching it historically, he prepares an architectural drawing of the building that specifies which paint hues and tints to use. Then, he acts as a liaison between owner and painter or contractor. Meagher's aim is to "applaud with paint what the architects have done with wood and plaster, and if necessary, to pick up where they left off." For example, if an arch or stenciled frieze has been left or taken off, he'll put it back on and

make each part of the building do the work it was meant to do. If a corbel has been minimized until it is simply decorative, Meagher will recommend renovating it so it appears to be working, that is, holding up the building. He will also recommend window treatment and tree and shrubbery planting, if needed. "After all," he explains, "I wouldn't dress a woman in an evening dress and then let her go to the party in sneakers. I look at houses in the same way."

He also tries to harmonize the property with its surroundings. In planning the color design on the huge Queen Anne at 1701 Franklin (page 20), Meagher had to take into consideration the stately architecture of the building itself, the brick church across the street, and the Stick and Georgian homes nearby. The building, now housing law offices, is painted in burnt umber, red, light and dark Venetian red, and white, with a garlanded frieze that delicately crowns the structure's majesty.

A Virginian by birth, Meagher arrived in San Francisco, to find a basically wooden city in need of paint: "All that joyous, whimsical detail of the Victorian gingerbread was being camouflaged in blanket coats of white, gray, or landlady buff." He did his own Victorian in a combination of blue, white, and tan. Then he persuaded the owner of a large building, which was being painted a deadly green, to let him add three judiciously chosen colors to revitalize the building.

Since then, he has relished restoring San Francisco's past splendor to a more glamorous present. He helped in the community effort to revive the original charms of the Victorians on Alamo Square. His work is gaining both national and international recognition.

The owners of the imposing "Imperial Russian Consulate" at 1198 Fulton (page 47) are Russian history buffs who are now content living in their gray, green, white, black, and Russian red house designed by Color Control. But at first, Meagher had to persuade them to let him paint just the tower, so they could see what the combination looked like. While working on the building, he accidentally discovered that the Corinthian columns on the front porch (two of the few cast-iron pillars in the city that survived two World War scrap iron collections) were made from molten iron. He had them unscrewed, dipped into paint remover, and then put back, shiny and new.

Meagher gives slide lectures showing how colorful exterior decoration is helping to preserve our architectural heritage. At the end of one presentation, a dignified old man told Meagher that he had been in Oakland during World War II, painting ships battleship gray. He remembered some rather pleasing Victorians in springy greens and yellows. But after the war, when properties were being refurbished after long neglect, the people used surplus Navy paint—and painted everything battleship gray. It seems that the traditionalists who look back fondly at battleship gray Victorians are simply remembering drab Navy surplus!

The Paints

"Painting is a matter of protection, chiefly, but is of most vital importance also in regard to the beauty of a house; there is rarely an exception when a light lovely color is not far preferable." *E. C. Hussey, 1874.*

In spite of the misguided sales pitches of aluminum siding, asbestos shingles, or textcoat (a mixture of hair, sand, and paint said to be "twenty times thicker than paint") salesmen, the best thing to preserve a wood house is paint. Ninety percent of all the Victorians built in San Francisco were made of virgin northern California redwood, which holds up under San Francisco's foggy weather better than any other wood. In fact, there are times when a painter can actually smell the perfume of newly cut redwood on a house that was built eighty years ago.

Choosing the right paint for Painted Ladies is sometimes harder than choosing the right color. San Francisco is tougher on houses than other cities—the sun, the fog, the moisture in the air are formidable assailants. Houses with southern exposures will generally last only 4½ years before the paint on the sills starts cracking. Paint on houses with a northern exposure can last up to fourteen years. But old buildings are more porous than new ones, so age, too, challenges painters.

Today, there are two kinds of paint to choose from, oil-based and latex. Oil-based paint fades; latex usually won't. Oil penetrates into the wood; latex (acrylic-based) paint clings to the wood surface with a thin rubbery film. In oil paint, the color pigment is close to the surface, so it fades gracefully. Resin coats the color in latex paint, so it doesn't fade as fast; when it does, it can be disastrous.

Colors on paint chips tend to be much less bright and vibrant than they are on a house. Some colors, which seem very bright when used, are muddy on a chip. The contrast between colors can make them "pop."

Butch Kardum learned, for instance, that red with red oxide can be very loud at first, but can tone down nicely and still remain crisp. Both he and Foster Meagher used Thalo blue (a rich, royal blue) on their first tries (their own houses) until they learned that the color faded terribly, turning an iridescent purple. Blues, in general, do not hold up as well as other colors. Meagher makes an effort to choose colors that are purposefully clear and luminous to begin with, so when they do fade, the balance between the contrasting shades will be maintained. He uses the Amer-

itone color key. Kardum uses the Bass Hueter color chart that follows the century-old earth tones of yellow, green, brown, ochre, cherry red, brown, or black. And he has found that, as in days gone by, muted tones last longer. Tony Canaletich recommends a combination of an oil-based sealer with a latex top coat that seems to wear longer than two coats of either.

No matter who does the painting, the preparation of the wood will directly affect the paint job. If scales of paint ("alligators") are left after the surface has been scraped or burned, the result will be a splotchy job that tends to flake off faster than it should. Spots that the painter misses are called "holidays"; they, too, mean a shorter-lasting paint job.

Costs

One hundred years ago, you could have bought for $1,000 a five-room Stick/Eastlake Queen Anne cottage with an ornamented bay window and imitation black walnut interior paneling. Two-story row houses could be had for under $3,500. A package of two houses and a building of flats on Bush Street was worth $165,000 nine years ago. It sold for $260,000 three years ago. Last year, the flats alone went for $225,000. With a little restoration, a four-flat Victorian on Buchanan that sold for $86,000 six years ago is now worth $250,000. So restoring Victorians is proving to be psychologically *and* financially rewarding. In fact, one real estate expert estimates that over the last five years, the value of Victorians has increased 35 percent *per year*.

What will it cost to turn a frumpy old model into a Painted Lady?

Color design alone can cost from $300 to $3,000. Painting a Victorian can cost from $1,400 to $5,000. As always, time and quality equal money. Generally, price depends on the painter, color consultant, and number of colors chosen. Some painters charge differently, depending on who they're painting the house for. People who genuinely love their homes, and live in them, will usually be charged less than, say, a real estate agent or promoter (who is painting merely to sell or to raise the rent) or the owner of an apartment or professional building.

Weather permitting, it can take one or two weeks to finish the front of a house, two to three weeks to do the whole house.

There are two types of scaffolding used by painters: pipe scaffolding that the scaffolding company puts up and rents for tall prices, and "fall" scaffolding—the planks/pulley and hooks apparatus used by 90 percent of the local painters. (It is cheaper, the painter puts it up himself, and most think it is actually safer.) Painters, especially if they use "fall" scaffolding, have to do the house from top to bottom, not from color to color. As a result painters frequently find themselves

applying up to ten colors all at once, floor by floor, while the paint is still wet. That takes painstaking care —and time.

It turns out that most creators of Painted Ladies do it more for the love of art than for money. One painter, who says he is charging what the market will bear for multicolor facades, adds that he makes fifty percent less on a four-color job (for which he charges $1,800) than on a two-color job, for which he asks $1,400. It takes twice the time to paint carefully, by hand, than it does to blast away with a spray gun. Isn't it wonderful to know that love of beauty still counts for something?

Finishing Touches

It's been said that up to 50 percent of the houses in some neighborhoods in San Francisco are camouflaged Victorians. The newly spotlighted Painted Ladies in these neighborhoods have inspired a new generation to look at their asbestos-shingled or stuccoed ordinary houses to see what they might have been in the past, and what they could be in the future.

Gussying up Victorians has zapped new life into lackluster, if architecturally remarkable, buildings and in some cases, has saved them. More than just a luxury for indulging nostalgia, the restoration of old homes has proven a very practical way to enjoy the present and an alternative to moving to the suburbs in order to find a comfortable, affordable home. The restoration of Victorians has changed dramatically from the catch-as-catch-can fix-ups of the 1960s to today, when investors, builders, and house lovers are turning a tidy profit. And making a renovated treasure out of a ramshackle wood frame building can still be a very personal, private enterprise.

Many homeowners credit the multicolor approach with highlighting the gingerbread detail that gives Victorians their special charm—a characteristic that has, until now, been buried by flat monotones or insensitive modernization. A sheaf of yellow wheat glows against a sky-blue background, a cherub's blue eyes follow you down the street, and a sunrise sends out shafts of gold. The result is a pleasure to the eye and spirit.

The men and women who are designing and painting San Francisco's Painted Ladies know each other and do sometimes bid on many of the same jobs. But, as Foster Meagher puts it, "Artists don't compete, they contribute." Butch Kardum adds, "You'll notice a lot of similarities in the work that we do, and I'm sure there's a point at which we all borrow something from each other and then evolve it our own way. The hardest thing for me, though, is not to copy myself."

There are four orgainzations actively helping to restore San Francisco's Victorians. Victorian Alliance is an "organization of Victorian freaks who own or

would like to own their own Victorian." The Alliance prepares helpful publications about researching buildings and neighborhoods, and there are regular meetings open to the public.

Foundation for San Francisco's Architectural Heritage is a nonprofit preservation organization dedicated to the conservation of architecturally and historically important San Francisco buildings. It promotes public awareness and has files of information on skilled workmen, salvage sources, craftsmen, wood grainers, marbleizers, furniture restorers, millworkers, and plaster casters. Heritage maintains the landmark Haas-Lilienthal House for the public's enjoyment.

San Francisco Victoriana is another knowledgeable supply source for the necessary materials and services. It encourages the restoration of original architectural character with the least amount of compromise in authentic design or materials. Victoriana is also being called upon to advise or participate in restorations across the country.

The Preservation Group believes in investing in the future by saving the past. They form an investment group of a limited partnership of members of the community, buy an endangered building, move it if necessary, restore it, and then sell it. This revolving build-up of funds has helped restore several important buildings in the city, including the Mish House (page 54) and the Phelps House, supposedly the oldest unaltered residence in San Francisco, built circa 1851.

Now, there is even a savings and loan specializing in mortgage loans for Victorian houses: the First Federal Savings & Loan of San Rafael, operated by a father and son team with a predilection for antique gingerbread. During ten years of providing loans for Victorians located in districts that other banks have redlined or refused to consider for mortgages, First Federal has never had a forceclosure. The bank protects itself through unique requirements, however. It deals only with owner-occupied homes; the owner must agree to bring the house up to code and restore the building in keeping with its original design.

Recently, FACE (Federally Assisted Code Enforcement) has enabled many homeowners in the Alamo Square area of the Western Addition to get low-interest, long-term loans to restore their Victorians. One house, purchased for $27,000 (with only $5,000 down and a $17,000 government loan), is now worth well over $100,000. FACE and RAP (Rehabilitation Assistance Program) have made use of government monies to spruce up other areas of town as well.

Government programs in Berkeley and Oakland have concentrated on rehabilitating old wooden Victorians. And there has been an upsurge of interest in Victorians in places as far away as Atlanta, Key West, and Boston.

The ripples spread. One man in Canada who read about Bob Buckter & Friends sent colorist Tony Canaletich a photograph of his house and a request for a color design by mail.

Using color design to brighten up the horizon for apartment buildings is now a national trend in the making. As one Los Angeles realtor said, "I want something San Francisco for my building."

"This is but a natural evolution and is in accord with the Californian's spirit of energy and enterprise, which at first often results in exaggeration and in the end produces the equal, if not the superior, to the work of any other land. . . ." So wrote J. C. Newsom in *Picturesque Houses,* 1890.

But look out. One color consultant has designs on San Francisco's Opera House and City Hall. And if the Ancient Greeks could do it. . . .

A Word About Captions

The captions for these Painted Ladies give the following information, in this order: street address, oldest known date of construction, architectural style, date of painting, name of color designer.

In San Francisco, very few streets are designated as streets or avenues, with the exception of Chinatown's Grant Avenue, and the numbered streets and avenues; thus, unless specified, all the addresses named are streets. Construction dates have been a puzzle. The 1906 earthquake and fire destroyed City Hall and its records, so most of the dates given here indicate the date when the City Water Department installed a meter. In many cases, the houses had not made use of city water because they had been served by private wells, springs, and cisterns for years. In other instances, the meter was turned on for an entire block, even before all the houses on that block were built.

In some cases, streets have been renumbered, adding to the confusion. Styles, too, are broken down into the four basic Victorian architectural styles. But San Franciscans have exuberantly blended and augmented their facades, in many cases creating a mélange that can only be called San Francisco style.

PACIFIC HEIGHTS

Pacific Heights is the area west of Van Ness Avenue that is, in fact, on the heights. Its boundaries follow an east-west ridge along the city's northern flank from Van Ness to the Presidio, and from the Bay to California Street. Here, for the sake of unity, we have extended this area three blocks south to Sutter Street, an area rising to the heights—along with the prices of its houses.

Three generations of San Francisco's business, political, and social leaders have built mansions, town houses, and sturdy middle-class homes climbing the heights and overlooking the Bay. In the 1860s, the land was a network of nurseries, vegetable farms, and open fields called Golden Gate Valley. Cow Hollow, now the Union Street area, was named after George W. Hatman's dairy ranch located there in the 1860s.

Today, this traditional dwelling place of San Francisco's upper crust displays the most conservative facades in the city.

(*Right*). 1913 Sacramento. 1870. Italianate. 1977. Painter unknown. A delightful example of how judicious bits of color fillip a house and make it "pop."

(*Below*). 1701 Franklin. 1895. Queen Anne/Colonial Revival. 1974. Color Control. Foster Meagher studied the architectural value and history of this imposing mansion, built for Edward Coleman and now San Francisco Landmark No. 54. He achieved the instant emotional impact he aimed for with the elegant, low-keyed color design. (See page 16).

(*Opposite*). 2022 California. 1885. Stick/Eastlake. 1976. Franklin Design. Designer Bert Franklin lives next door and wanted a color scheme which would both harmonize with his own house and be pleasant to see every day. A dozen layers of paint had to be burned off, and millwork and hardware had to be replaced, for this richly decorated grand dame (originally built for Sam Foorman, then sold to Judge J. Morrison) to be put to rights.

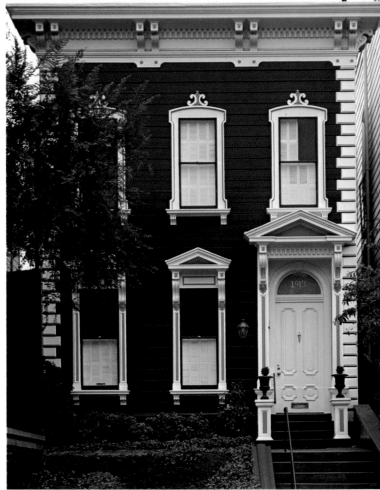

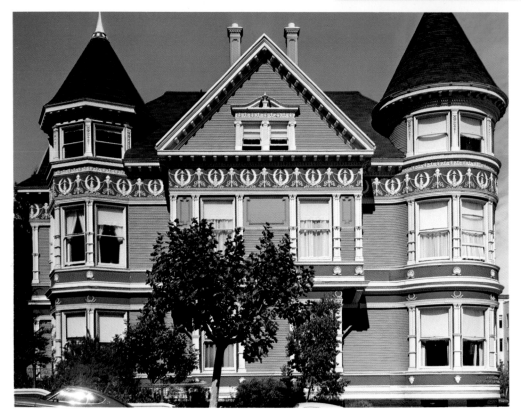

20

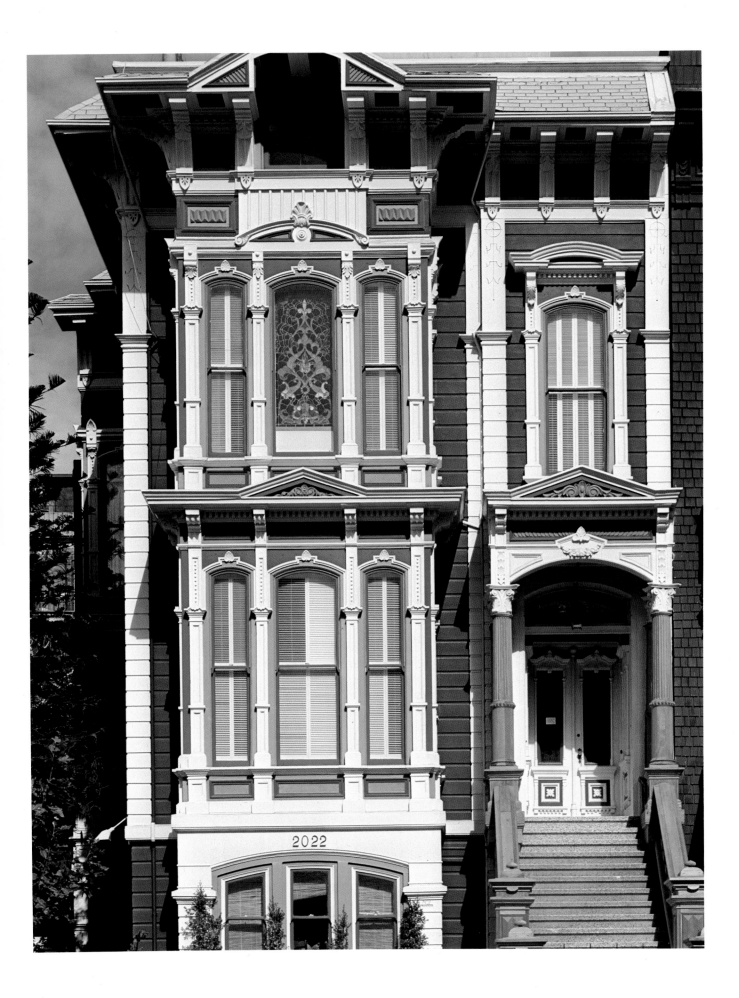

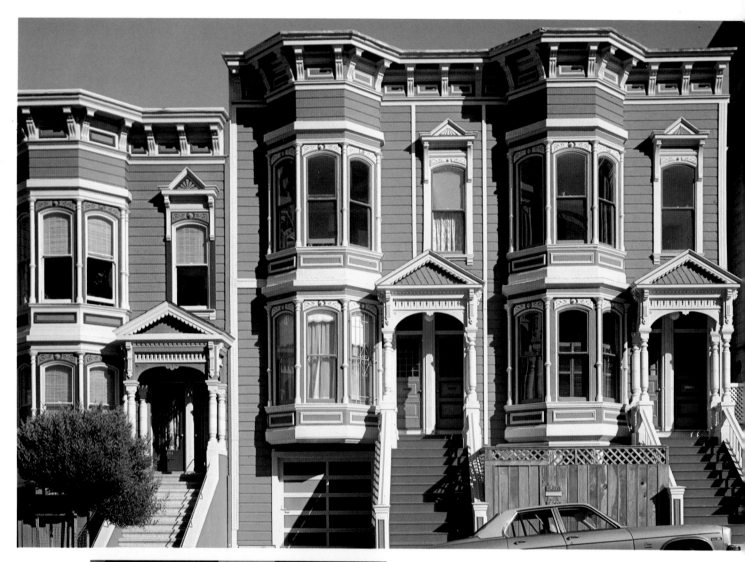

(*Above*). 1814–22 Bush. These Italianate row houses with slanted bays were built in the 1870s. The owners had their houses painted individually, but they talked to each other to be sure that the buildings would all blend—at least in tone.

(*Left*). 2107–09 Pine. 1890. Stick/Eastlake. 1972. The owners, one of whom is an art teacher, designed and painted this house themselves.

(*Opposite, left*). 2011–15 Pine. 1884. Stick/Eastlake. 1977. Jim Heig chose yellow and white, with ochre and bright blue accents because he likes the way it all works together. This overview does not do justice to the intricacy of the details.

(*Opposite, right*). 2139–43 Pine. 1881. Stick/Eastlake. 1973. Owner Don Parodi designed the elegant colors for this imposing facade.

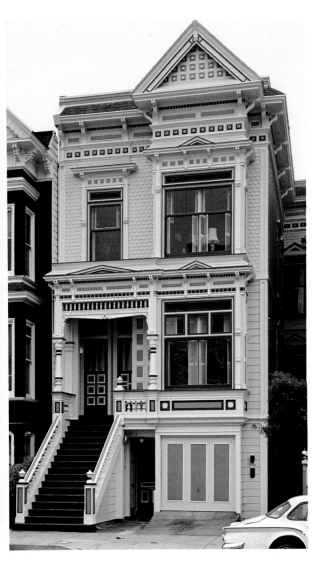

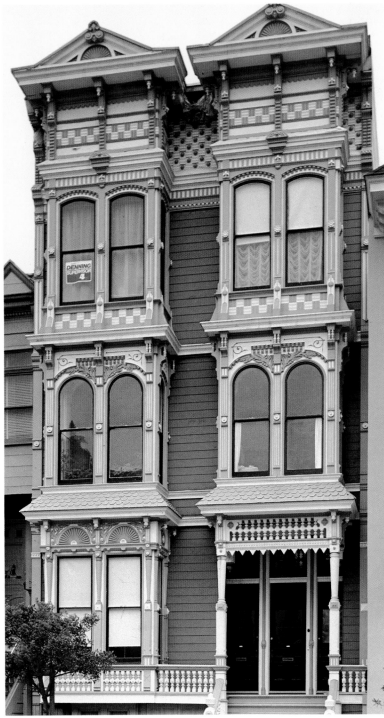

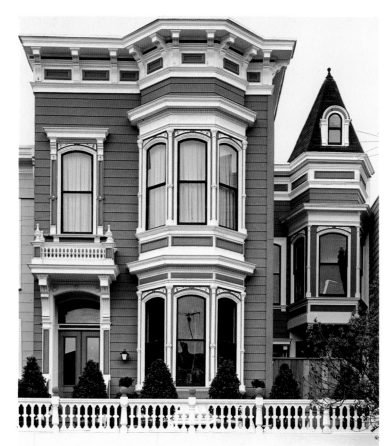

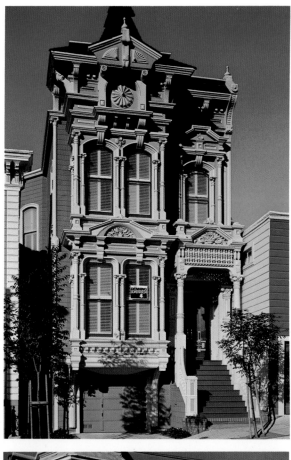

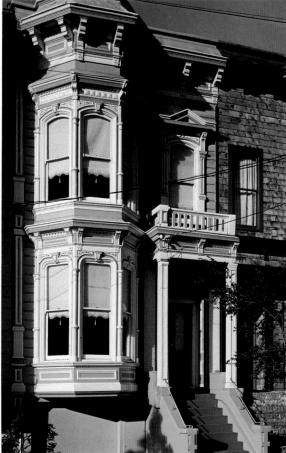

(*Above, left*). 2018 Bush. 1878. Italianate. 1977. This typical slanted-bay Italianate with an unusual, arched side ambulatory had been, until 1976, stripped and stuccoed. The owners worked with San Francisco Victoriana for thirteen months to restore the building, inside and out. They chose the unique color combination after consulting with designers Jane Awlan and Raymond Benson.

(*Above, right*). 1737 Webster. 1886. Stick/Eastlake. 1976. Butch Kardum. This magnificent structure is the only one left in San Francisco to be built by the Newsom Brothers. Originally, it cost $5,000 and was owned by J. J. Volner. In 1974, it was moved twelve blocks, from 773 Turk, as part of a joint Heritage/San Francisco Redevelopment Agency project. It is now protected by the National Register of Historic Places.

(*Right*). 1955 Webster. 1886. Italianate. 1977. Paul Scherer. Half of a Hinkel-built double house, this side has been allowed to retain its original splendor, while the other half has been unfortunately altered. Paul and Anne Scherer gravitate to earth tones. And when they used some leftover beige paint on the fireplace in their Wedgwood blue living room, they liked it so much they decided to try it on the exterior of the house. Although the soft, warm blend they achieved is pleasing to the eye, some neighbors felt that they had hardly scaled the heights of good taste. The Scherers had to rise to their home's defense in the face of such comments as "Everybody makes mistakes" or "A little loud, isn't it?"

(*Opposite*). 30–32 Orben Place. 1876. Italianate. 1975. Designer Burt Orben completely restored the facade on this house, created a snappy color design, and refurbished six other houses on his block. Three years ago, his neighbors petitioned to have their street, once called Middle Street, renamed—Orben Place!

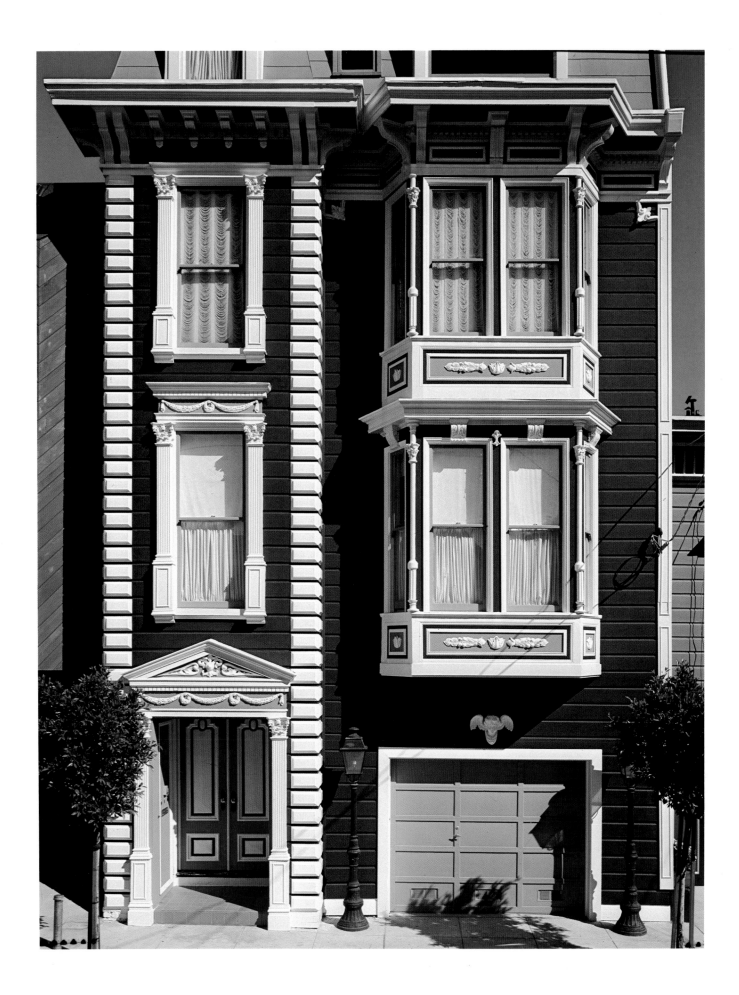

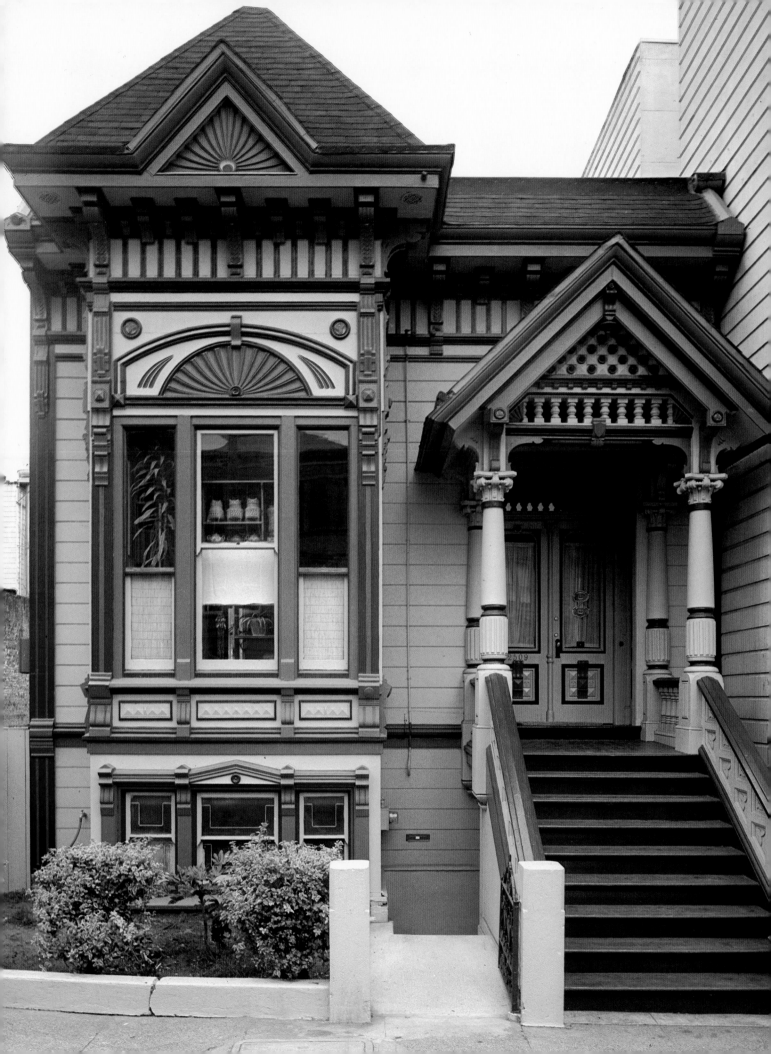

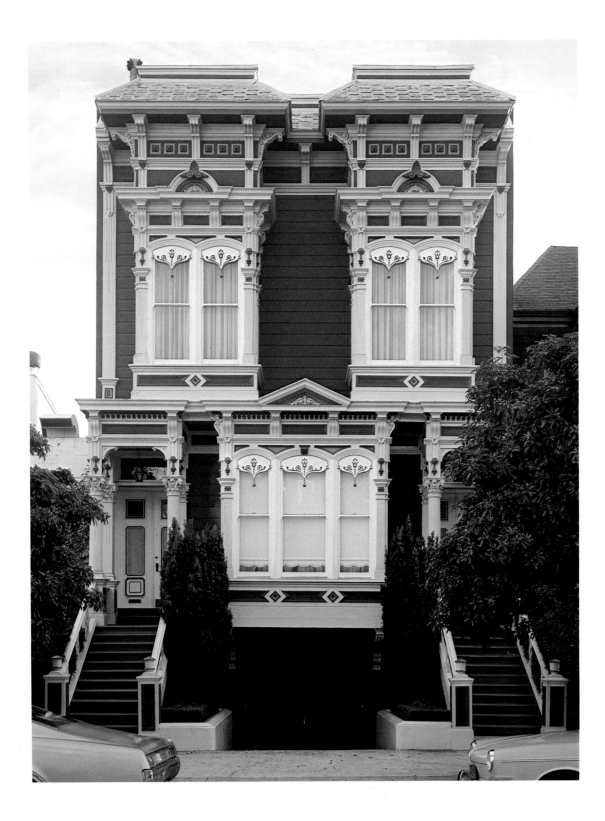

(*Opposite*). 2509 Sacramento. 1886. Stick style. 1977. Laurel Birch, a designer now gaining recognition for her Chinese enamel jewelry, designed this richly ornamented cottage to reflect her feelings about the Victorian age.

(*Above*). 2537–41 Washington. 1885. Stick/Eastlake double house. 1972. The owners of this meticulously restored home (once belonging to the La Place family, owners of the turn-of-the-century restaurant the Old Poodle Dog) have experimented with different multicolor schemes over the years, progressing to stronger colors as paint technology improved. The house was condemned and was a total shambles in the 1960s, when the present owners moved in. They painted it in three shades of beige. Although the neighbors thought it too gaudy, they were supportive because they were so pleased the house had been restored.

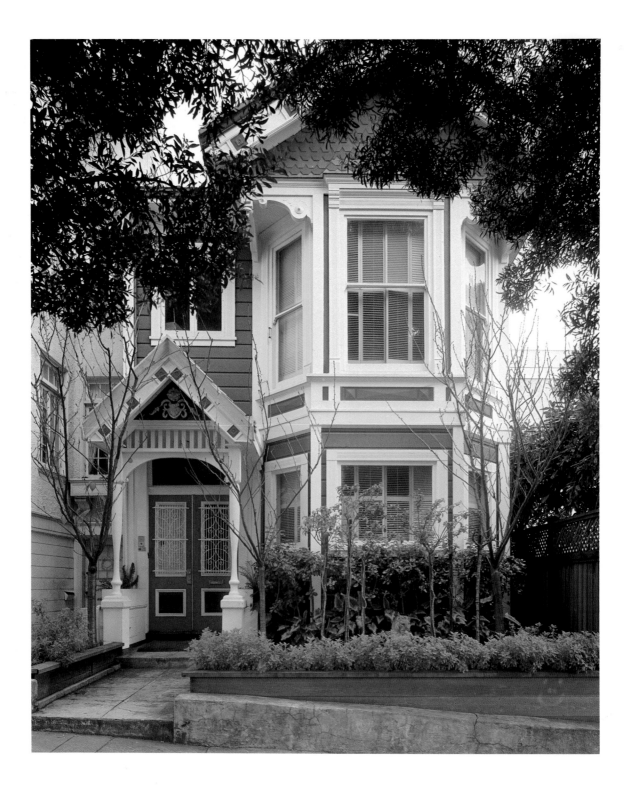

(*Above*). 2373 Washington. 1886. Carpenter Gothic. (The second story was added in 1910.) 1975. Color Control. After making many pastel sketches of her Victorian cottage, the owner decided she "might as well go all out" and use her favorite color, purple.

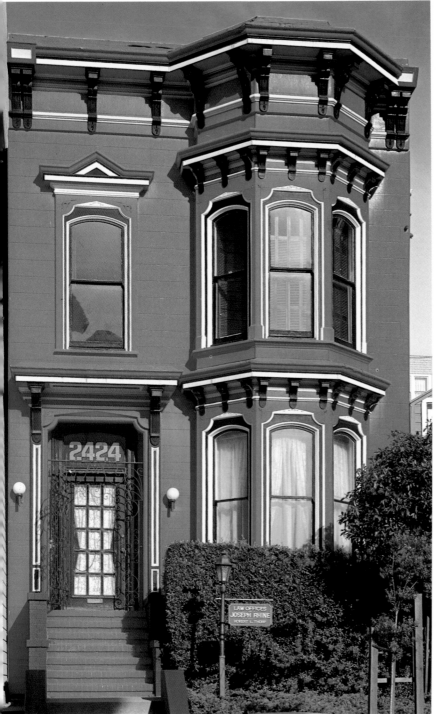

(Left). 2424 Pine. 1895. Italianate. 1969. Lawyers Joseph Rhine and Michael Kennedy were branded Communists when they were involved with the Free Speech Movement in Berkeley and were defending the likes of Timothy Leary and Angela Davis. To put their best front forward, the owners redid their offices in red: ashtrays, coffee cups, typewriters. As you can see, they completed the statement in blazing style.

(Below). 3029–35 Fillmore. 1896. Queen Anne row house. 1976. Bob Buckter & Friends. Driving around the city with Bob Buckter, the owner was uncertain how far her sense of aesthetics would let her depart from the building's previous black-and-white incarnation. The result adorns the top of a hardware store, and, the owner feels, justifies her faith in Buckter's "excellent taste."

(Bottom). 3047–49 Fillmore. 1897. Italianate. 1976. Butch Kardum and the owner chose the colors for this house together. They wanted something bright and cheery and succeeded in setting a trend for their Union Street neighbors.

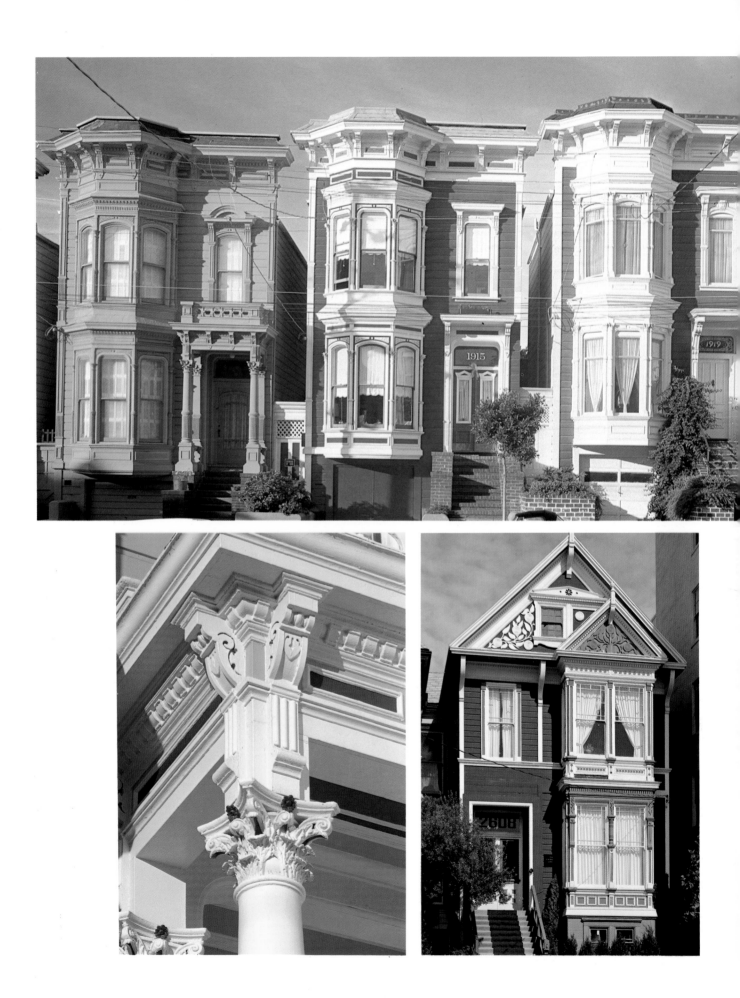

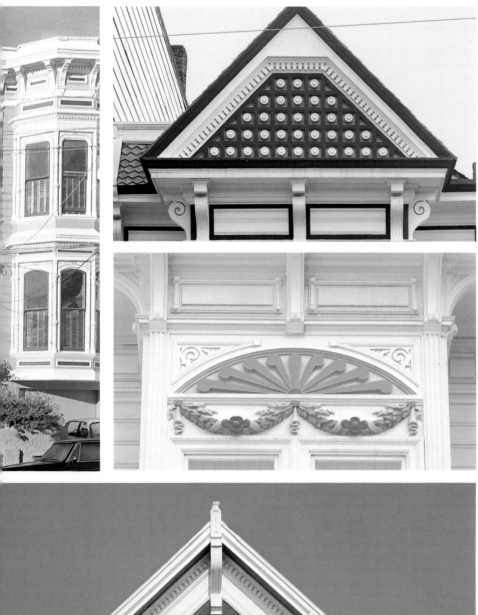

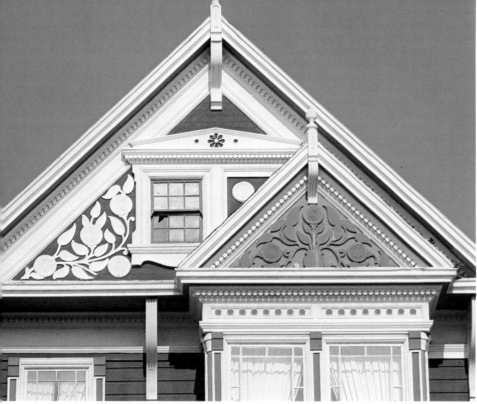

(*Opposite, above*). 1907–23 Pierce. This block of Italianate row houses was built between 1875 and 1885.

(*Opposite, below left*). 1923 Pierce. 1881. Italianate, built by a contractor named Hinkel. 1977. Jane Chope and Pat Regan worked together to give the house a bright, elegant look and to highlight the carving and detail on the pillars and panels. The flowers were painted navy blue on one capital as a lark, but the owners liked it so much they continued the motif.

(*Left, above*). 1814 Scott. 1875. Stick style. 1974. Color Control. This is one of the last waffle-pattern cottages in San Francisco.

(*Left, center*). 2207–09 Sutter. 1887. Italianate/Stick style. 1972. When Tip Hillan was restoring the front of the house, he went to the hardware store and bought, at random, as many cheerful colors as he thought would go together. Since the body color of the house was white, he wanted to accent the gingerbread. He experimented a little with each of the eight colors he had chosen until he found the right combination.

(*Opposite, below right*). 2608 California and detail of gable (*left, below*). 1887. Queen Anne row house with Eastlake influence. 1974. Designer Wes Slease wanted to do something original for this one-time house of pleasure, as well as create a flow-through of color between an identical building in peach on one side and a very tall apartment building on the other. Using those two buildings as bookends, he chose colors that would harmonize with the structures, yet had not been used on Victorians before.

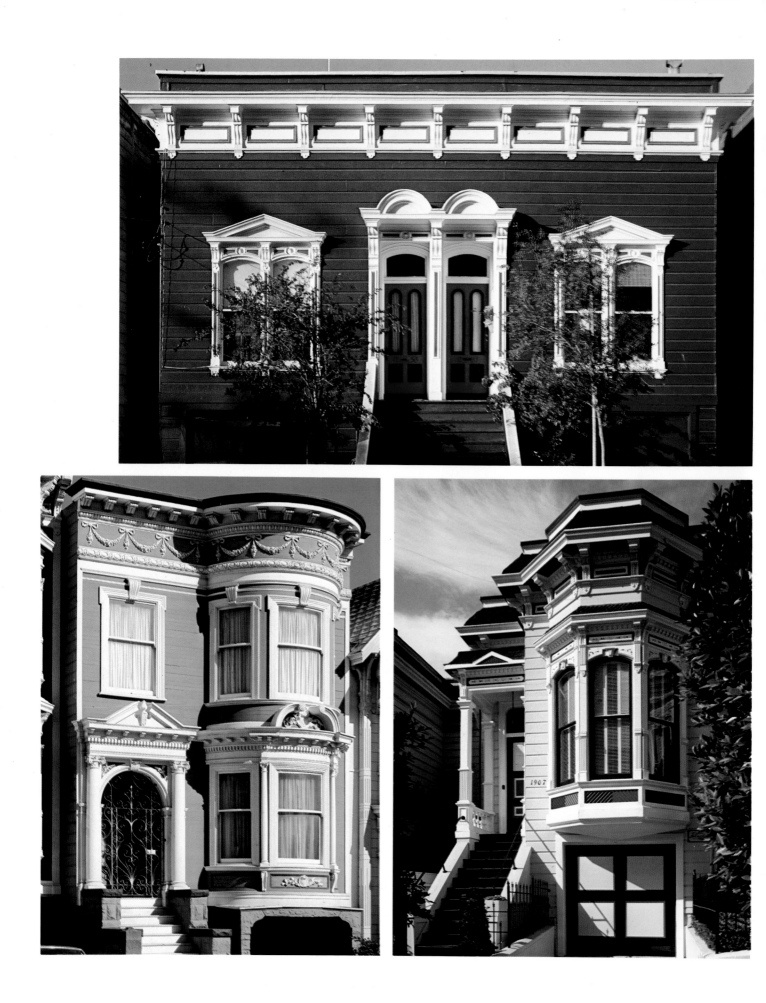

(*Opposite, above*). 1853–55 Scott. 1978. Italianate. 1974. Sandra **Musser** chose colors to highlight the trim on her pristine cottage.

(*Opposite, below left*). 1918 Divisadero. 1904. 1973. Franklin Design. This house, which combines styles that range from Italianate to French Revival, was built as a twenty-fifth wedding-anniversary present by a contractor who lived next door. It was one of the first houses in the neighborhood to be painted like this.

(*Opposite, below right*). 1907 Baker. 1882. Italianate. 1977. Built by William F. Lewis, father of the noted San Francisco author Oscar Lewis, this little cottage was basically yellow when the new owner moved in. He set off the Victorian moldings and details in sunny colors.

(*Above*). 1916 Broderick. 1894. Queen Anne. 1976. In looking at this building, the owner thought of Hansel and Gretel's house in the woods. No one had tried to paint the details in order to highlight them until Douglas Kibble, who manages the building, rose to the occasion.

(*Right*). 3100 Clay. 1896. Queen Anne tower. 1970. The owner worked closely with an architect, restoring both interior and exterior of this majestic tower house, to create one of the first Painted Ladies in the neighborhood. The color design was based on an 1899 picture of the house, showing these kinds of contrasts and outlining of detail.

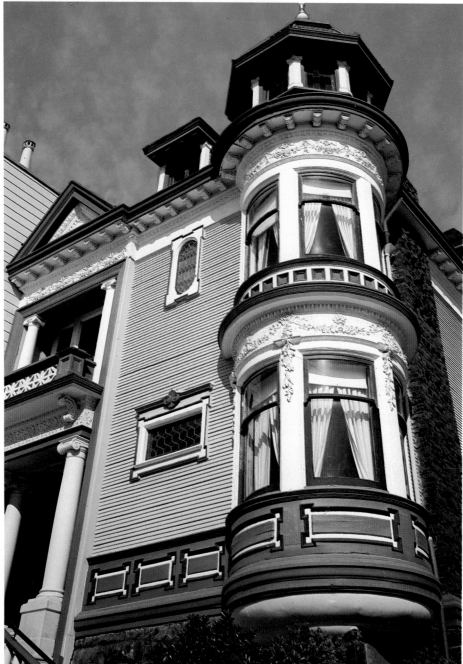

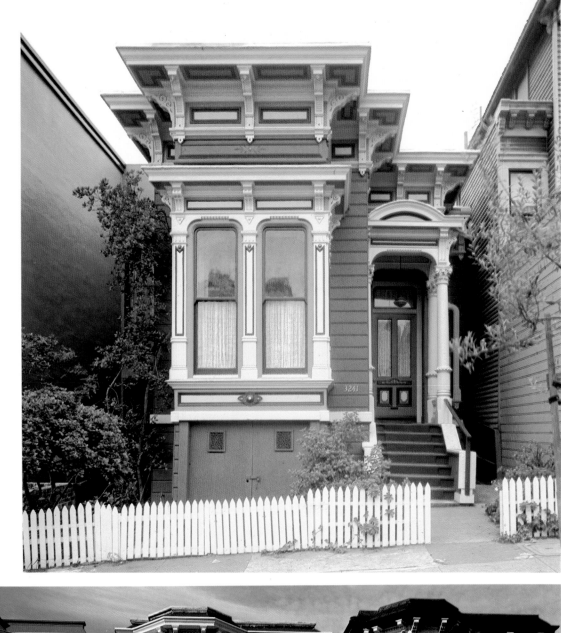

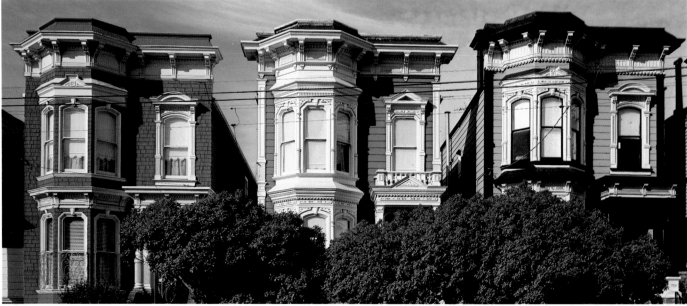

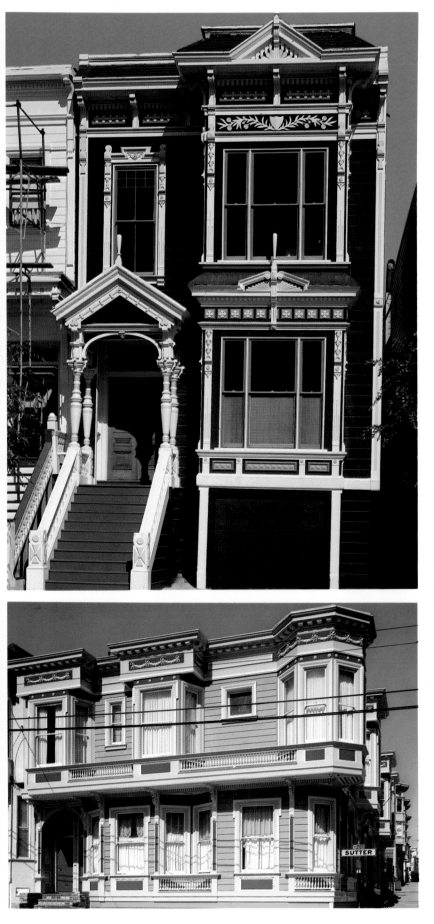

(*Opposite, above*). 3241 Sacramento. 1883. Stick style. 1976. Tony Canaletich and Bob Buckter & Friends made the most of the detail on this quaint little house. The different shades of green elegantly bring out the sense of depth created by the receding levels of this medical building. Framed by greenery and a white picket fence, this deceptively small house graces a well-traveled shopping street.

(*Opposite, below*). 1705–09 Broderick. This block of Italianate houses with slanted bay windows was built in the early 1880s.

(*Left, above*). 2860–62 Pine. 1887. Stick/Eastlake. 1975. Architect Larry Mock wanted a Victorian for a long time. This is his first house. He wanted something crisp, bright, cheerful, with a dark background for the vibrant details. The neighbors were surprised that the design was "so aggressive," but now they like it. And the next time he paints, he'll use a high-gloss paint to give it that extra sparkle.

(*Left, below*). 2500–02 Sutter. 1894. Italianate. 1977. Alan Greenspan felt that since this was an Italianate structure, it should be graced with the colors of the Italian flag! Once covered in stucco, the 125-foot facade was the largest frontal restoration completed in the city and took six months to do.

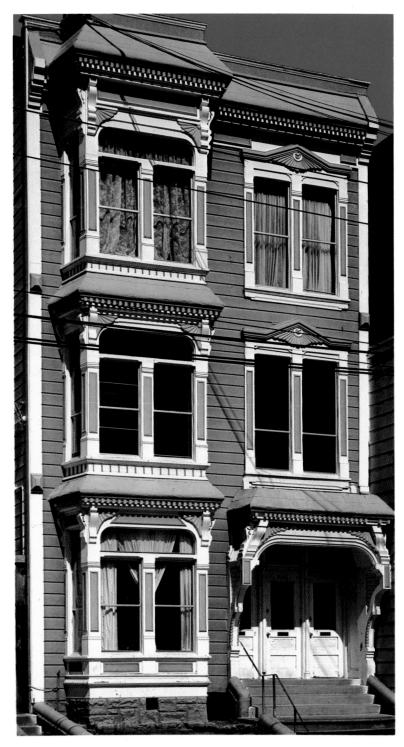

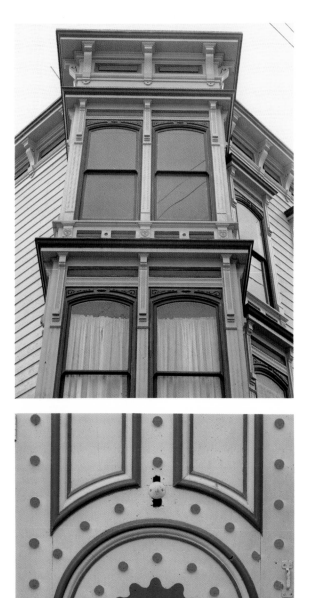

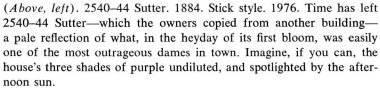

(*Above, left*). 2540–44 Sutter. 1884. Stick style. 1976. Time has left 2540–44 Sutter—which the owners copied from another building— a pale reflection of what, in the heyday of its first bloom, was easily one of the most outrageous dames in town. Imagine, if you can, the house's three shades of purple undiluted, and spotlighted by the afternoon sun.

(*Above, right*). 2701 Sutter and detail (*right*). 1889. Stick style. 1975. Veterinarian Mort Linder and his artist wife Virginia originally painted this house red, with yellow trim, the same year the "hippie house" (see page 48) was finished. When the red faded, they reversed the colors and used yellow, with red and blue trim.

THE WESTERN ADDITION

The Western Addition was added to the west of the Gold Rush city—west of Van Ness Avenue—by the charter of 1851. The Van Ness Ordinance of 1855 extended a grid pattern of streets south of California and west to Divisadero, then the city boundary. But the area was mostly open country until the 1870s and 1880s, when it became a prime residential district with easy cable car and streetcar access to the main sector of town. Row houses seemed to spring up block by block overnight.

After the 1906 fire, Fillmore Street became the city's shopping center for a time, and more people moved in hastily. From about 1910 on, the area between Geary and Pine, from Octavia to Fillmore, became known as Japantown. During World War II the Western Addition filled up with Southern Blacks flocking to the Bay Area to work in the booming shipyards. The area declined to transient flats and then to ghetto, until it reached its nadir with the mass destruction of its Victorians for "urban development"—the building of a freeway and public housing.

Today, individuals, neighborhood groups such as the Alamo Square Neighborhood Committee, and preservation groups are working to rejuvenate and restore some of the proudest Victorian Painted Ladies in the country.

San Francisco historian Charles Caldwell Dobie once described the row upon row of Western Addition Victorians, with their mingled motifs of Baroque, Corinthian, Gothic, Byzantine, and Georgian ornamentation, as "an outbreak of architectural lunacy." To make it easier for you to see, we've defined this area as having boundaries going from Golden Gate to Market Street, Octavia to Duboce, and over to Divisadero, Fell, and Stanyan.

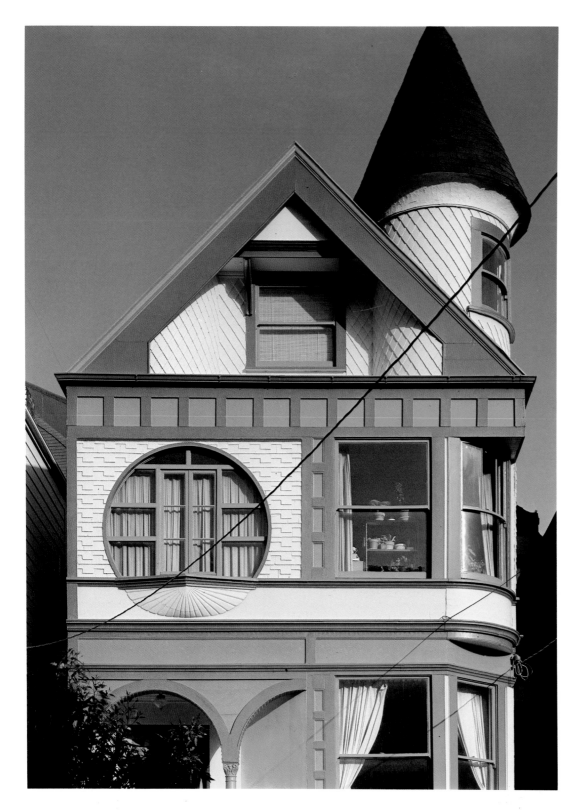

(*Above*). 230 Ashbury. 1892. Modified Queen Anne tower house. 1975. Owner Michael McKinley and friends tried different combinations and variations of six or seven colors —over a two-year period—before choosing these bright warm colors.

(*Opposite, above left*). 405 Lyon. 1888. Stick style. 1977. One of the renters in this house worked with her friends to paint this building—in spite of four landlords in three years—because she really cares about the building and the neighborhood.

(*Opposite, above right*). 1429 Hayes. 1886. Stick/Eastlake. 1976. Carmencita Lewis chose the design for her family's home, and her father painted it.

(*Opposite, below left and right*). 1456–58 Grove. Details of entrance and stairway. 1887. Stick. 1977. Gloria Mayes monograms and designs jewelry. She designed the house using her favorite colors: jade-green, antique-yellow, and redwood brick.

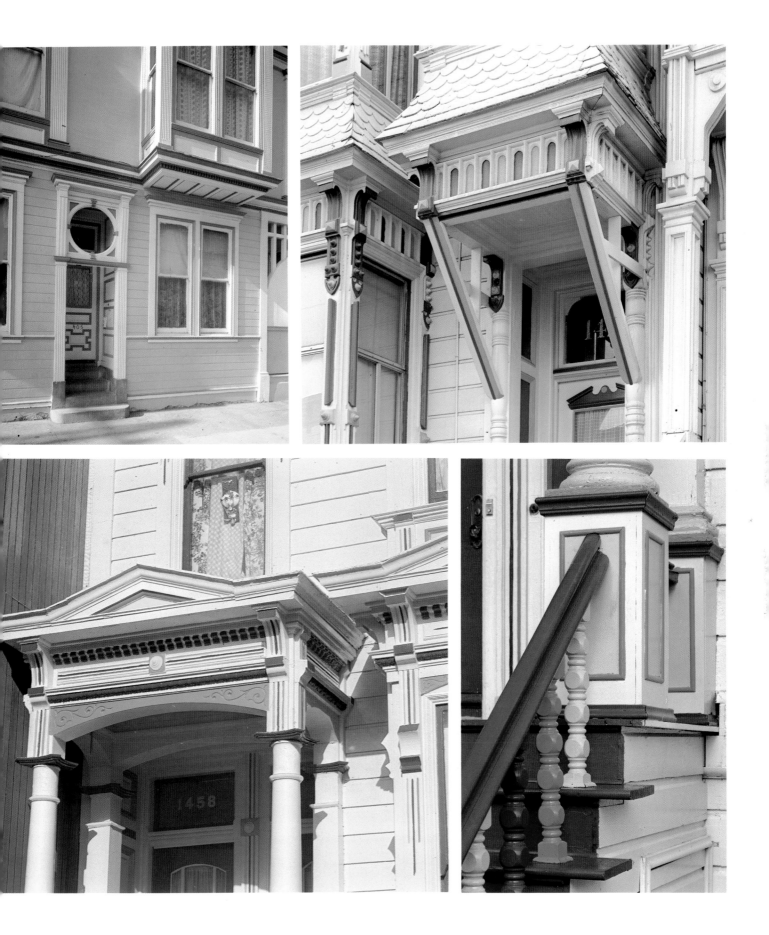

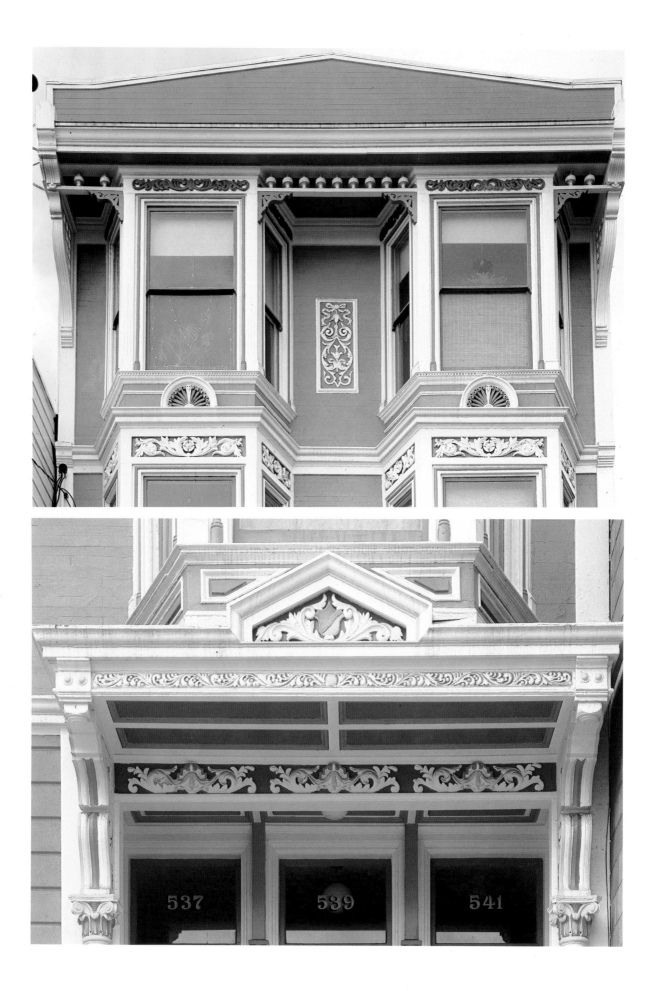

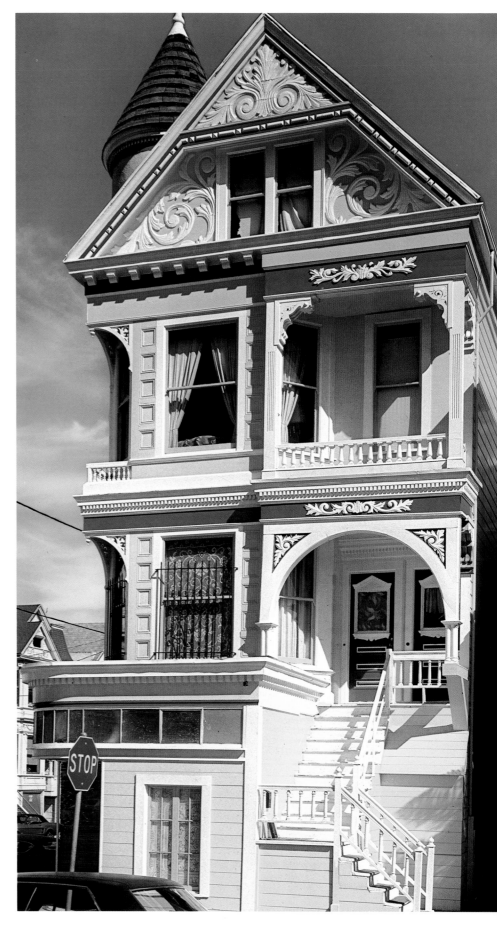

(*Opposite, above and below*). 537–41 Baker. Details of gable and entrance. 1891. Italianate with slanted bays. 1976. The owner, who has done a number of houses, painted this unusual one himself.

(*Right*). 1597 Fulton. 1892. Queen Anne tower house. 1977. Jean Summers designed this summery combination of colors to highlight the floral motifs.

41

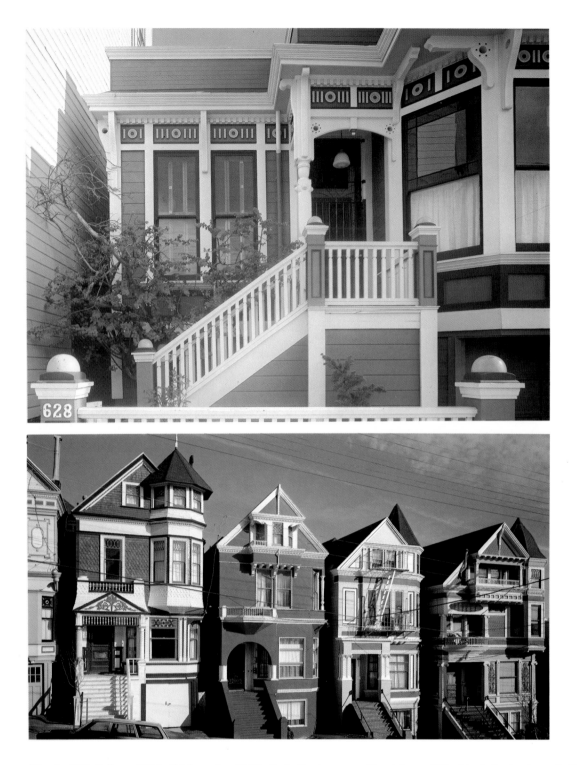

(*Top*). 628 Baker. 1886. Stick style. 1976. Bob Buckter & Friends designed this house for the owners, who wanted a flamboyant and very strong statement for prospective buyers. It worked.

(*Above*). 700–06 Broderick. This block of Queen Anne tower and row houses was built in 1892. Each building was painted individually. For number 700, the star of the group, Blissful Painting used the colors of the tiles decorating the entrance.

(*Opposite*). 1671–73 Golden Gate Avenue. 1894. Stick/ Eastlake. 1975–76. Bob Buckter & Friends worked with previous owners, who helped choose the colors after much discussion. The present owner knew that the house was noted for being architecturally outstanding, but he had driven by the house several years ago and didn't particularly like it. Then, when he was looking for a house to buy, the real estate agent told him to drive by again. He saw it, all dressed up in its new paint job, thought "Wow!" and bought it. Now he's buying other buildings and carefully thinking about their color design to make them fit into their neighborhoods. And his motto is "Brighten a corner where you are."

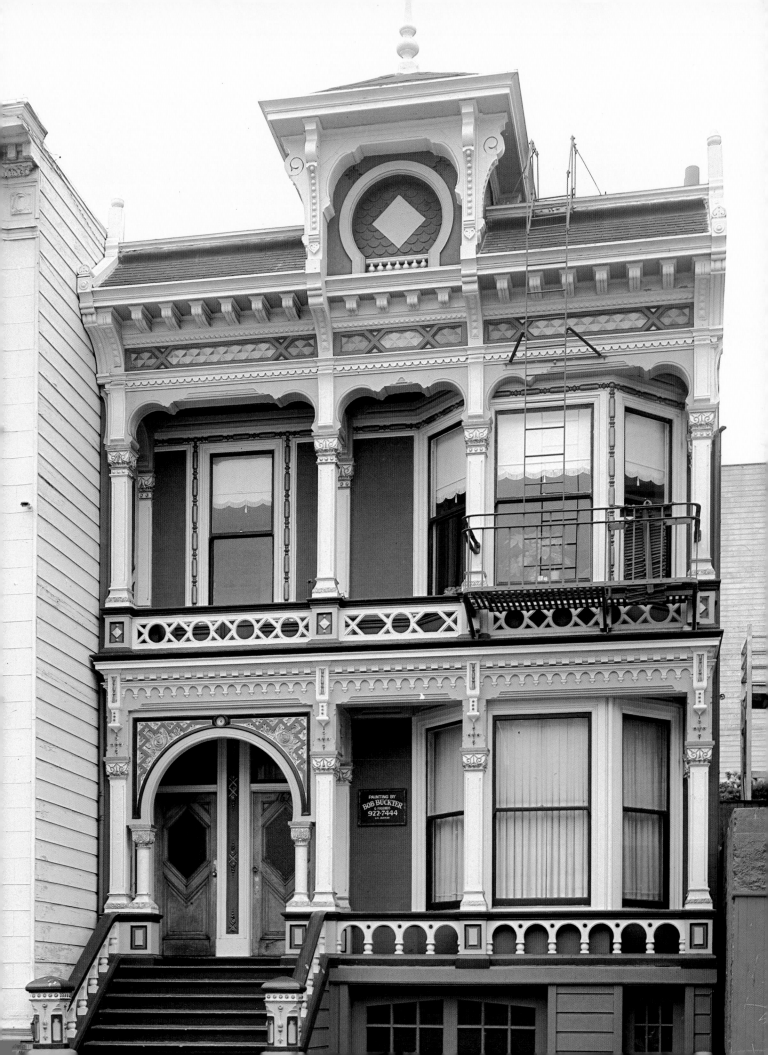

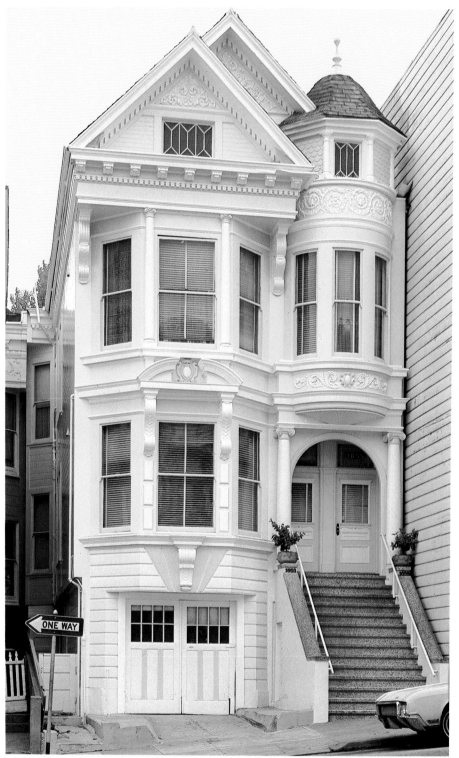

(*Left*). 1653 Golden Gate Avenue. 1901. Queen Anne row house. 1977. Mrs. and Mr. James O. Brown chose pale pink and blue for their house just because they liked the colors—and they thought this combination would be different.

(*Below*). 1451–53 McAllister. 1882. Stick/Eastlake. 1973. Jazon Wonders, of Blissful Painting, painted this old baronial home (with its elegantly designed newel post shown here) using the owners' choice of colors, and giving them his own touch of magic.

(*Opposite*). 1347 McAllister. 1880. Baroque French Revival. 1974. Rick Mackota. This extraordinary town house, built by a tobacco merchant, boasts a ballroom—and a great view of downtown—on the top floor. It is one of three French Revival mansions in San Francisco.

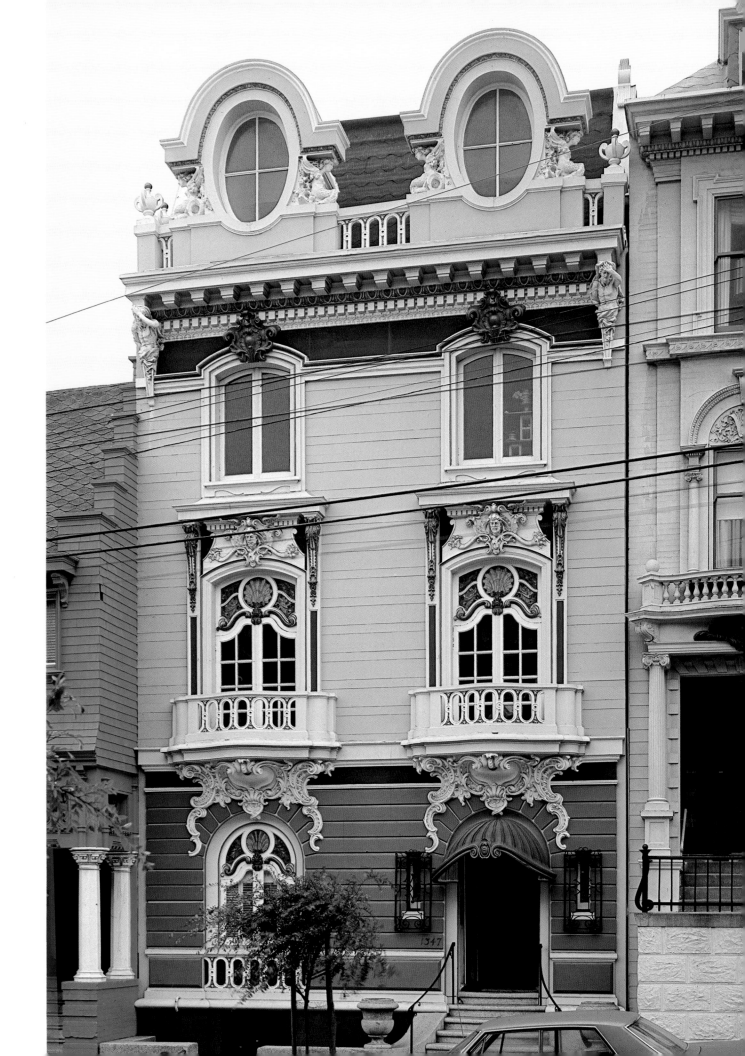

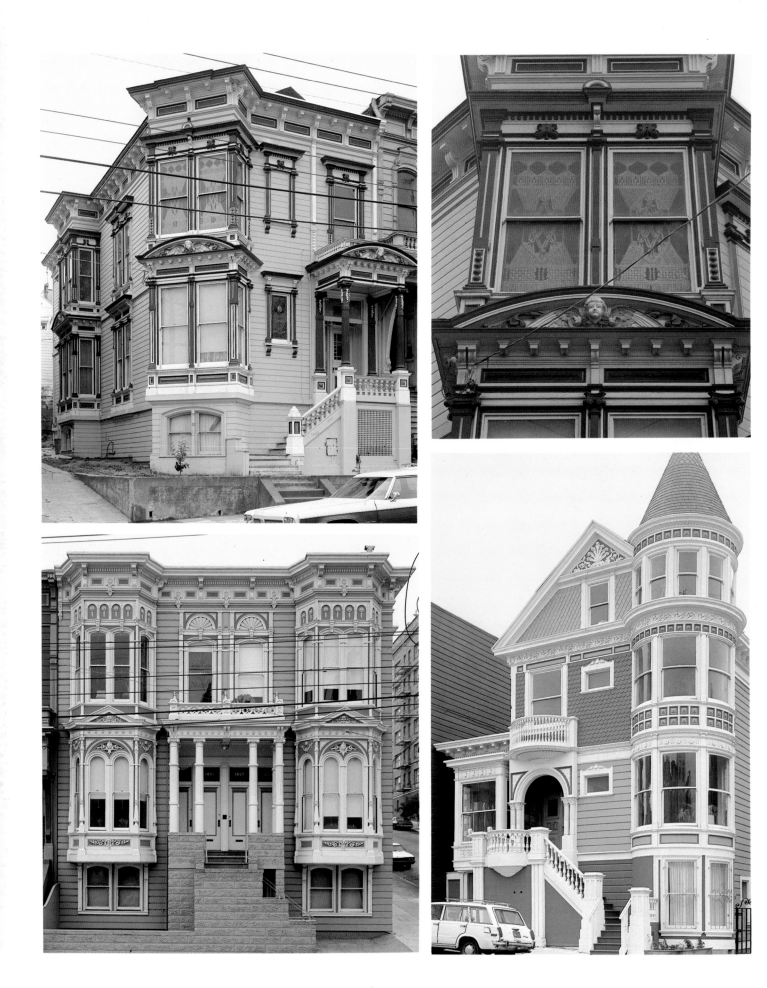

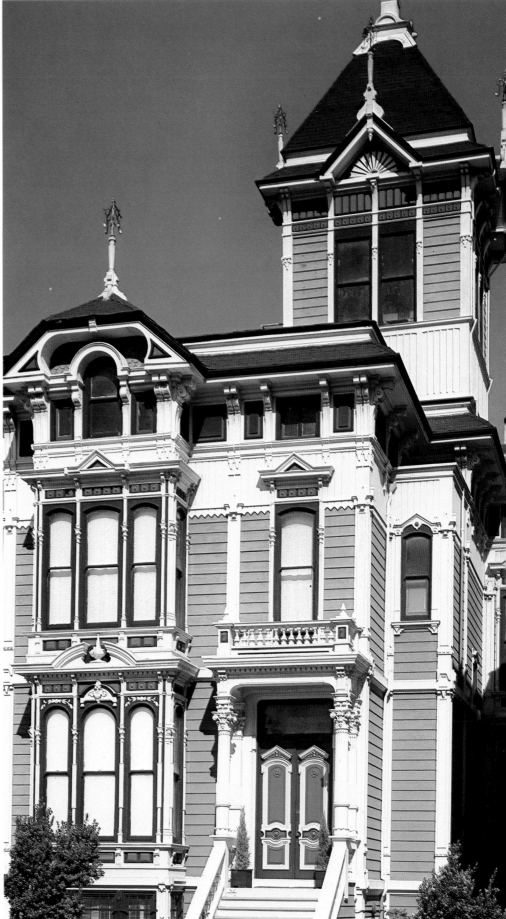

(*Opposite, above left and right*). 1463–65 McAllister and detail. 1880. Stick/Eastlake. 1973. Jazon Wonders. When the woman who owned the house next door saw what Blissful Painting had done, she asked them to do hers "basically green" but with decorations. Jazon even gave the building's guardian cupids a third blue eye. Five years later, it's still one of the town's leading Painted Ladies.

(*Opposite, below left*). 1491–99 McAllister. 1891. Italianate/Stick/Eastlake. 1976. Butch Kardum used the owner's choice of colors in this felicitous combination to overshadow the modern stone entry.

(*Opposite, below right*). 1255 Fulton. 1875. Queen Anne tower house. 1976. Color Control. Originally a farmhouse, this building was remodeled in 1890 to include a kitchen. A dining room and garages have since been added.

(*Right*). 1198 Fulton. 1875. Stick/Italian/Eastlake/Villa. 1972. Color Control. The colors in this formidable dwelling are meant to reflect its colorful past. Built by Henry Geilfuss to house the Imperial Russian Consulate, the architecture is very close to that of the Carson House in Eureka. In 1889, noted baker William Westerfeld moved in and hooked into the city water system. In 1904, John J. Mahony, one of the builders of the Palace and St. Francis Hotels, moved in. The house was used again by the Russians in the 1930s—this time as a social club by members of the Russian community. The present owners are now restoring the interior, from ballroom to tower.

(*Right*). 908 Steiner. 1899. Stick style. 1967. Known in San Francisco as the "psychedelic house," or the "hippie house," this is the prototype of all the sophisticated multicolors in town. The people who were crashing there at the time (one girl, Maija Gegeris, signed her name on it) all used artists' brushes and painted on as many colors as they could find. At one time, an eight-foot-long papier-mâché crocodile also graced the side of the house.

(*Opposite, above right*). 850 Steiner. 1899. Queen Anne tower house. 1976. Bernard Kearny and Gordon Zimmerman designed this house—built as a wedding present by the last owner's father—to harmonize with the other houses on the block, picking up a yellow on one side of them, an aqua on the other. The owners work closely with their neighborhood association to restore and preserve the area's homes and park.

(*Opposite, above left*). 1062 Fulton. 1911. Stick/Eastlake. 1975. The owner, who chose the colors after driving around the city, has photos of the house taken before 1906. However the only official date we have for it is 1911, when the Water Department began keeping records and noted that the house had three baths and six water closets.

(*Opposite, below left*). 722–24 Fillmore. 1890. Stick/Eastlake. 1977. Bob and Pam Liner explained, "We felt that the house had a nice spirit to it and we wanted the colors to fit that. We wanted the mood on the inside of the house (which shows off our collection of amusement park animals and fixtures) to reflect on the outside, and we wanted to highlight the incredible millwork."

(*Opposite, below right*). 256 Page. 1876. Stick style. 1974. James Aldrich wanted his house to be bright and colorful, in contrast to the gray and black he had painted it previously. It was the first home in the area to be done like this, and it inspired others in the neighborhood to spruce up their houses.

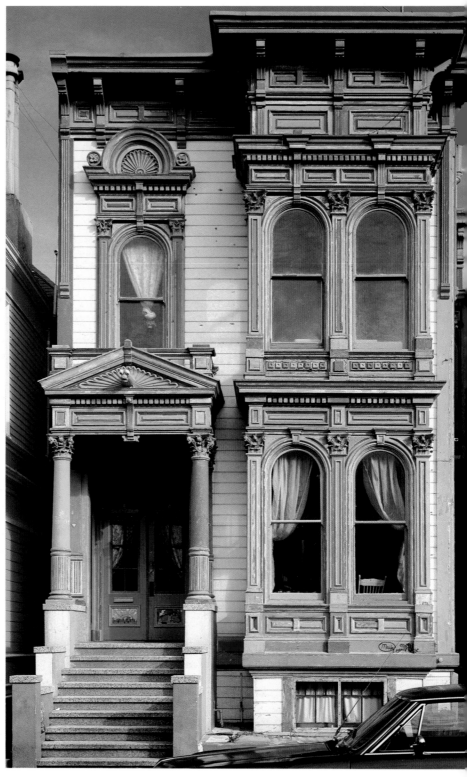

48

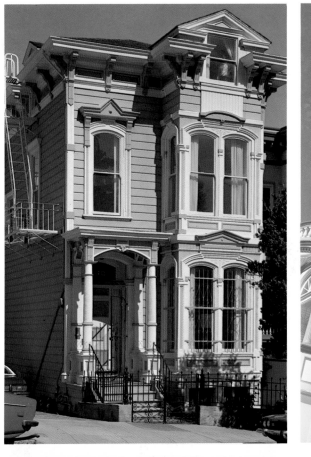
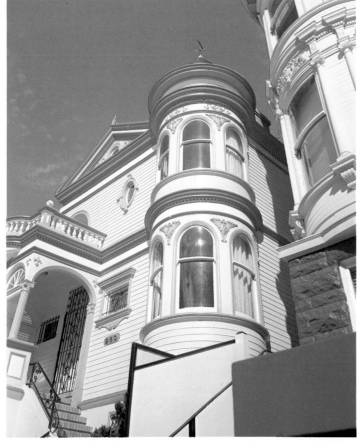
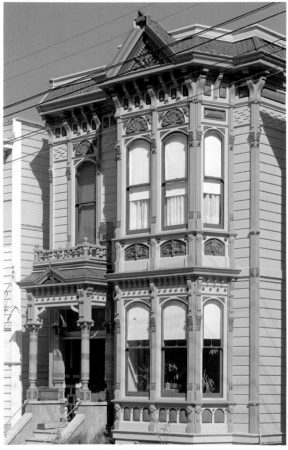
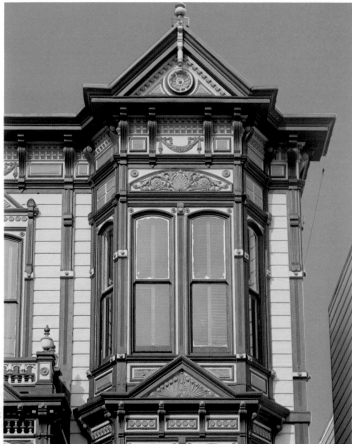

(*Right*). 838 Page. 1887. Italianate. 1975. When we tried to find who did the color design on this saucy cottage, repainted since this photograph was taken, we learned that it was "just someone the previous owner gave work to."

(*Below, left*). 864–66 Page. 1888. Stick style. 1976. Donna Kosukowich always liked the idea of a cheery yellow house. Her friends helped her make the dream a reality.

(*Below, right*). 850 Page. 1885. Stick style Queen House. 856–58 Page. 1889. Stick style King House. 1974. Michael Allen chose Rastafarian colors—red and green, brown, gold, and amber—because he considered them peaceful colors. The painters were sure the house would look like a Christmas tree, but Allen persuaded them to use the tones of red and green he had selected. It worked. A man, who owned several houses across the street, saw Morley and Michael taking pictures of these buildings and, talking to David Allen. He asked, "Don't you want to take a picture of my houses? You only want to take pictures of the pretty ones?" And Michael and Morley just smiled. Later, the man talked to Allen, wondering whether the buildings' property values were going up. He has since started to paint his own houses.

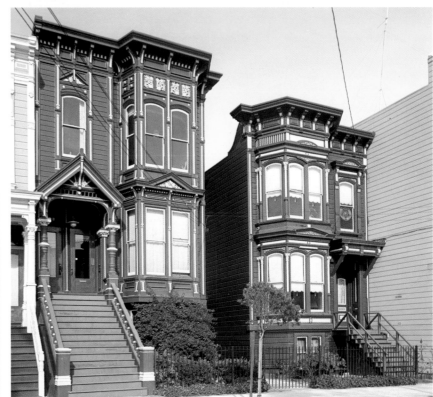

HAIGHT ASHBURY
and NOE VALLEY

Haight Ashbury

Thanks to the hippies, the Haight Ashbury section is as famous in this era as the Barbary Coast was in an earlier one. Prototypes for multicolored Victorians were created here by artists who wanted psychedelic colors in every part of their lives. "Flower power" gave way to drugs and crime, which by 1970 brought the community to its lowest point. Since then, the Haight has become a thriving, growing neighborhood along the Panhandle, with middle-class residents painting and sprucing up their homes. With the help of an active neighborhood association, Haight Street is blooming once again. We've demarcated this area with Divisadero/Castro streets, Oak, Stanyan, and 17th Streets.

Noe Valley

Noe Valley, named for José Noe, last Mexican *alcalde* (mayor) of Yerba Buena, is the town's counterpart to Greenwich Village—a blend of coffee shops, restaurants, antique stores, and private homes united by a strong sense of community. Noe Valley begins, for our purposes, where the Haight leaves off, at 17th Street. It extends to 28th Street and from Dolores to Diamond. Castro Street is the epicenter of San Francisco's gay community, and many of the city's creative people find the area's sunny hillsides a hospitable milieu for plying their arts.

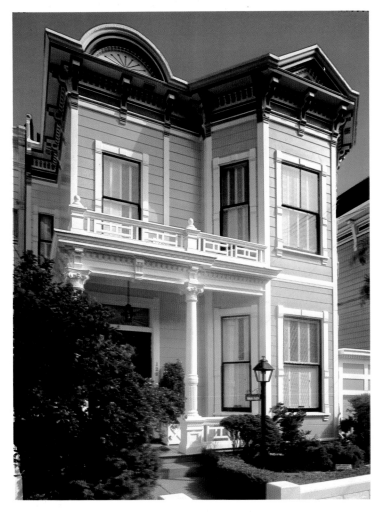

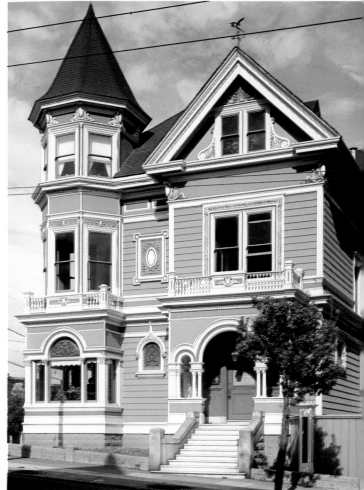

(*Opposite, above left*). 126 Divisadero. 1889. Italianate with slanted bays. 1977. Michael Barry is a designer who felt that the people who live in this house are special, so their house should be special. He found cast-iron toys, including a little carousel horse, during the excavation undertaken to restore this house. He also found letters dating from 1887, proving, he says, that the house had been occupied long before the Water Department sent its first bill.

(*Opposite, above right*). 1080 Haight with detail of window (*opposite, below*) and detail of entrance (*below*). 1895. Queen Anne tower house. 1975. Bob Buckter chose the colors of this architecturally significant home after working closely with San Francisco Victoriana on the complete interior and exterior restoration. Architect Fred T. Rabin designed the house for John C. Spencer, M.D. It is one of only 300 San Francisco tower houses that have survived intact; it is especially noteworthy for its five-sided tower that rests upon a large square bay with Palladian windows.

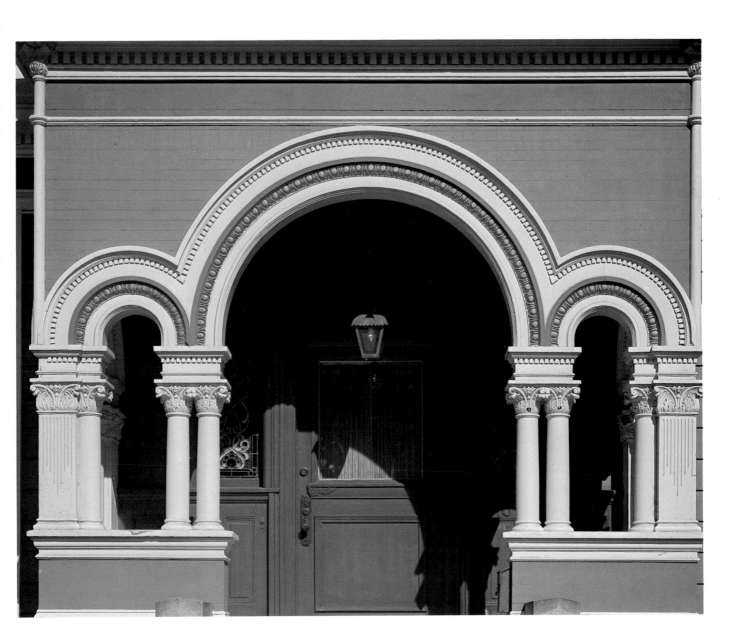

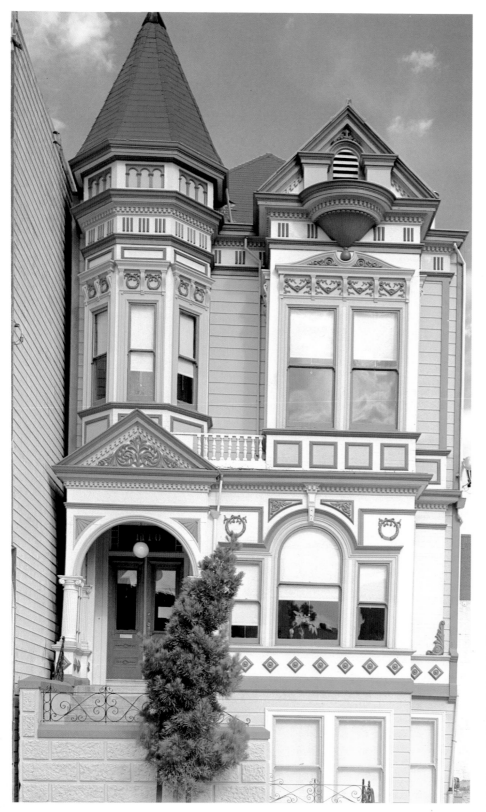

(*Left*). 1140 Oak. 1886. Queen Anne tower house. 1977. Local Color. The owner had played around with color design unsuccessfully and then painted his house all white, but he "got a million complaints" from the neighbors, and questions like "when are you going to paint your house?" Inspired by the Mish House across the street, he finally called in Local Color to redo the entire building.

(*Opposite*). 1153 Oak. 1885. Stick/Eastlake. 1975. Bob Buckter & Friends painted the Mish House, San Francisco Landmark No. 62, working with San Francisco's Preservation Group. Tony Canaletich used a dazzling palette of over a dozen colors to pick up every curve and whorl in the gingerbread. Photographic conditions prevented us from doing justice to all of this remarkably beautiful facade. (See page 11.)

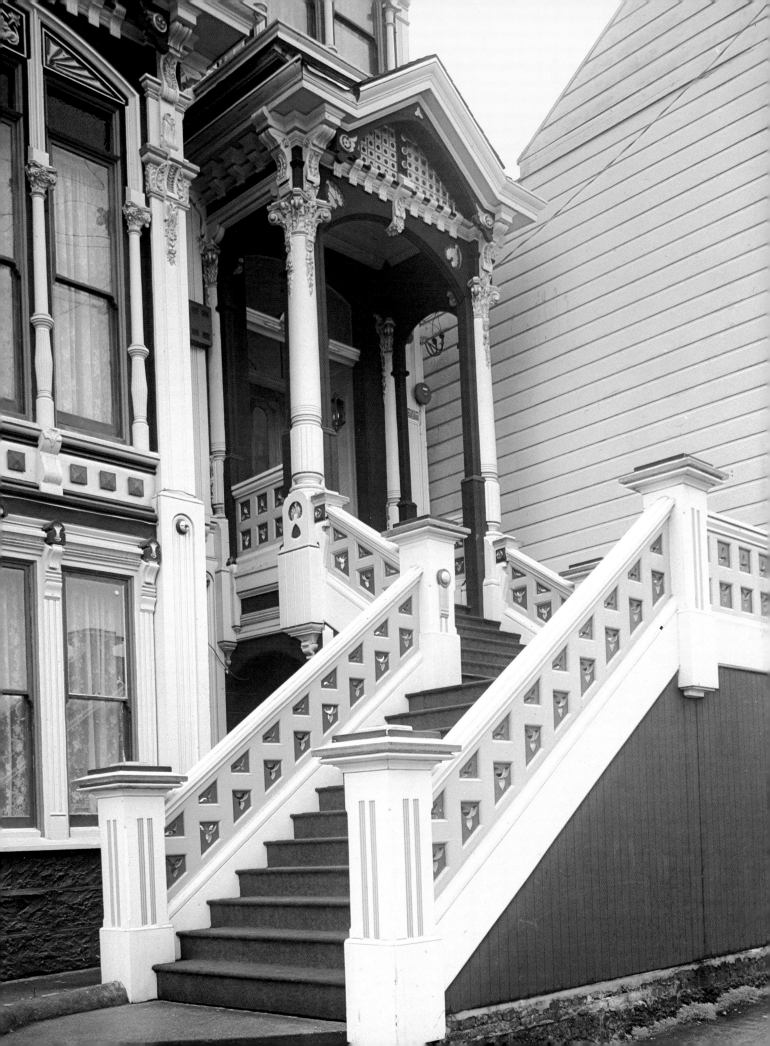

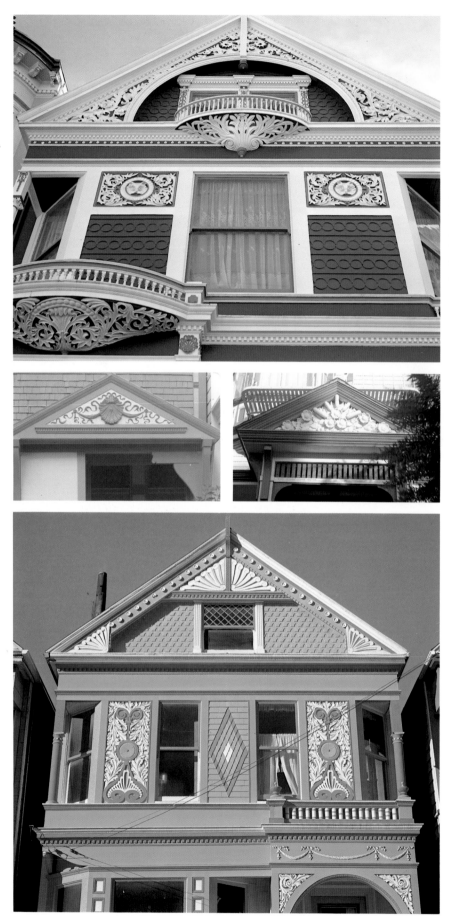

(*Left, above*). 1777 Page. 1894. Queen Ann row house. 1977. Gary Head selected the colors for this house, which was built originally for Senator Alan Cranston's grandfather. The trim has a delicate laciness which must remind one of the co-owners of the beautiful collection of doilies her mother and grandmother have crocheted.

(*Center, left*). 1910–12 Page. 1903. Queen Anne tower house. 1975. When Kathy Munderloh saw this house, hidden behind a flat camouflage green, she knew it was for her because she'd always had a fantasy of living in a castle. Pleased that the colors she chose have mellowed well, she is trying now to persuade the neighbors into painting their houses.

(*Center, right*). 772 Ashbury. 1889. Queen Anne row house with witches' hat. 1973. Built to last by a lumberman, this house even boasts a redwood fireplace. Although limited by the choice of available colors when they painted last time, its owners, the Sanders, are determined to make this charming and unusual pediment of corn and flowers a bouquet of color the next time they repaint the house.

(*Left, below*). 721 Cole. 1895. Queen Anne row house. 1972. Mike Tuve started painting his gloriously golden house in 1972; it is still a work in progress. He has tried to keep a balance between the orange-and-white trim.

(*Opposite, above*). 667–71 Ashbury. 1905. Slanted bay Italianate. 1976. Mitch Bell painted this apartment house in cheery yellows to brighten up a dreary neighborhood. The eagle on the wall, holding marijuana, was decorated with banners as a salute to the Bicentennial—making the house an obligatory stop for tour buses.

(*Opposite, below left*). 734–A & B Ashbury. 1904. Stick/Eastlake. 1976. The Scaffold Company. This was the first house in the neighborhood to be glossed over in this color scheme. Now, other houses in the area are following along.

(*Opposite, below right*). 54–56 Lower Terrace. 1891. Stick style. 1974. Jim Shinkle bought this house, the oldest one in the Buena Vista District, for the view. He's been restoring it inside and out since 1956. He chose the colors and added the finials to make the house look taller.

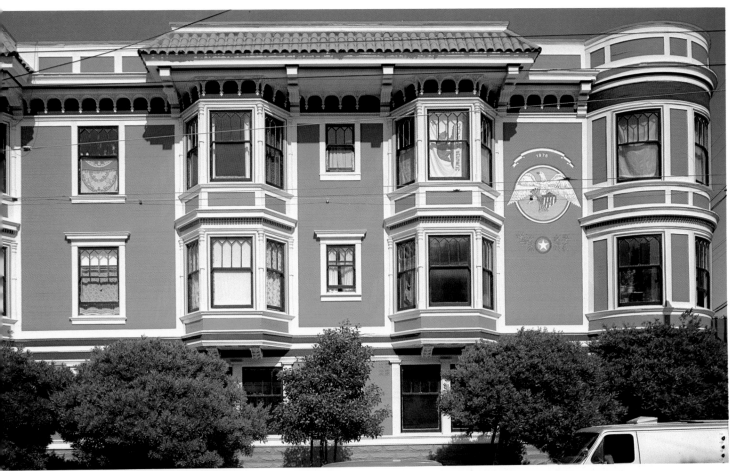

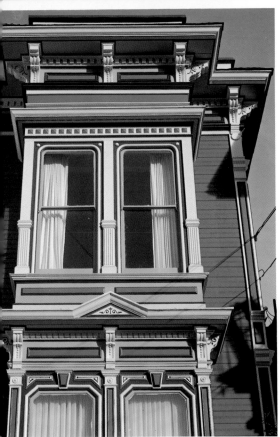

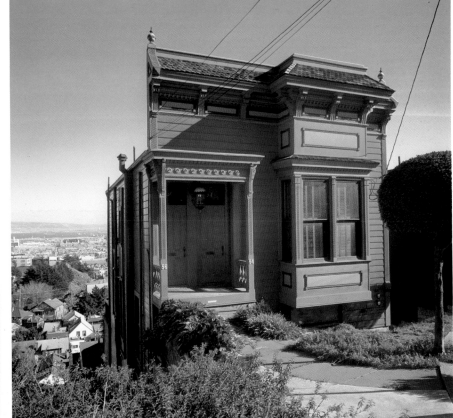

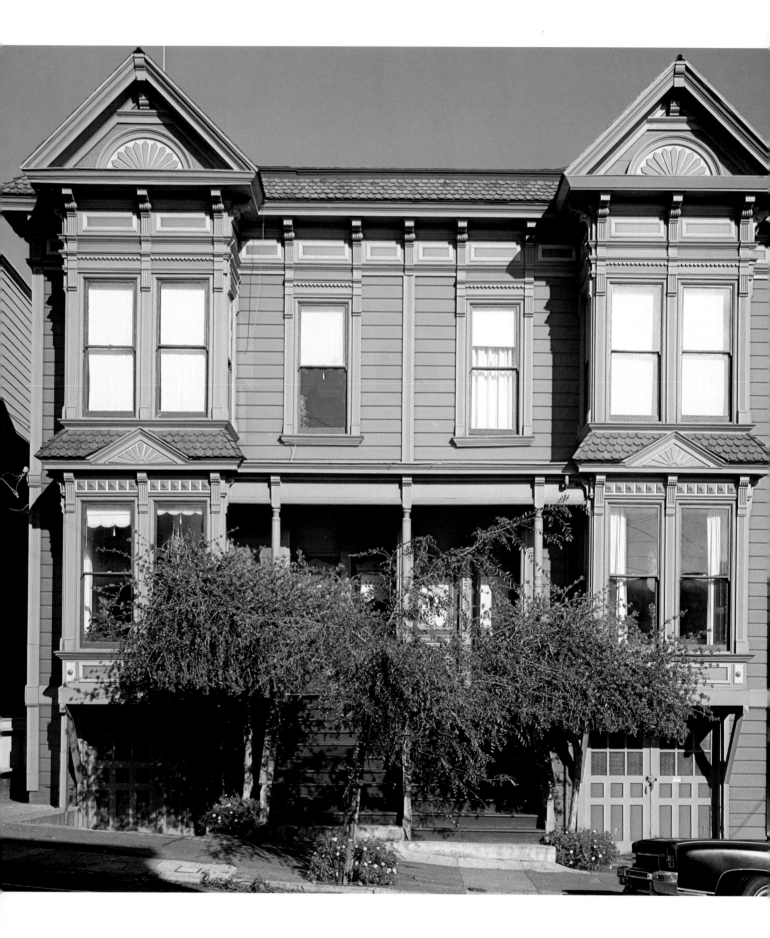

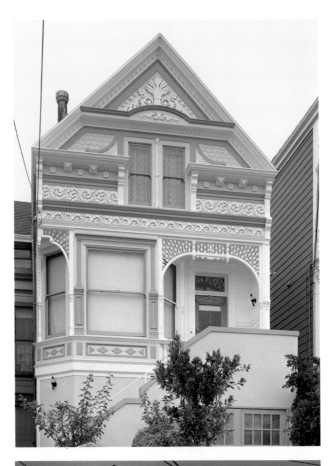

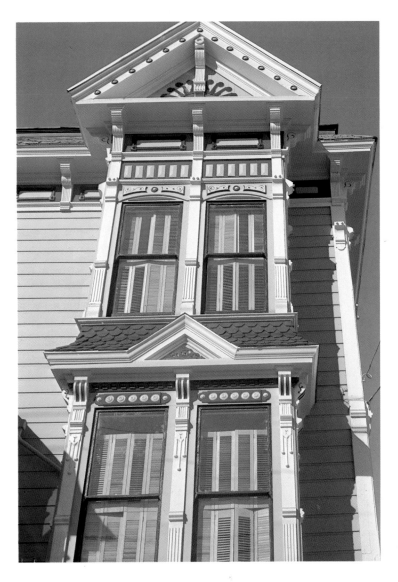

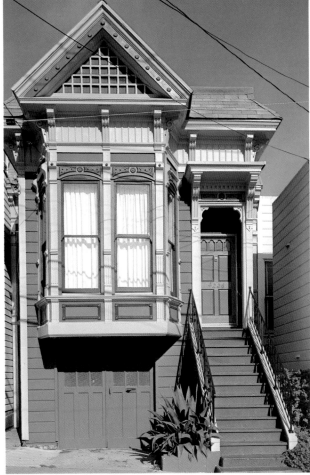

(*Opposite*). 4186–92 17th Street. 1892. Stick style. 1976. The owner rode around town with Jazon Wonders of Blissful Painting before deciding on this interesting combination of colors.

(*Above, left*). 4417 20th Street. 1886. Queen Anne row house. 1977. Before painting their house, the owners drew a picture of it on which to test colors. They aimed for something that wasn't too flashy and would harmonize with the house next door.

(*Above, right*). 4200 23rd Street. 1892. Stick style. 1977. Bob Buckter & Friends played up all the signature millwork of contractor Fernando Nelson with their color design.

(*Left*). 4226 23rd Street. 1892. Stick style. 1975. Tony Canaletich and Bob Buckter & Friends painted this sweetheart of a house, built by Fernando Nelson. The owner reports, "Everybody who goes by stops to look."

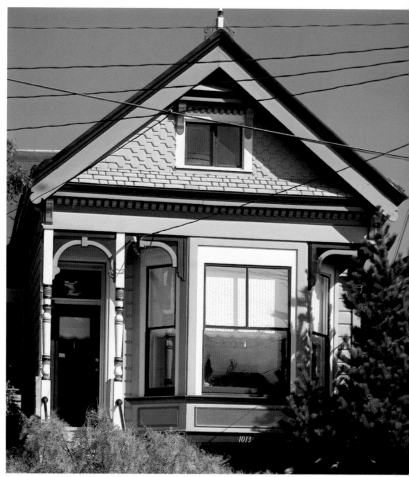

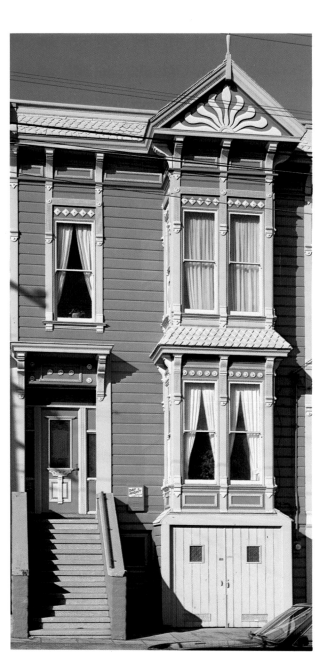

(*Above*). 1013 Castro. 1894. Queen Anne cottage. 1973. Sharon Litzky, an art teacher, first thought she'd dress up her "Quaker drab" cottage in green, white, blue, and red; then she decided to juxtapose the purple and red. The painter she had hired gasped: "I forgot you live in Noe Valley." And the artist now living in the house agrees: "Lavender with a touch of red is politically correct for this area." When the painter refused, Sharon painted the porch columns and the finial herself.

(*Left*). 838 Diamond. 1894. Stick/Eastlake. 1974. Jim Goldsmith restored this graceful home, once one in a row of four, which now brightens up the entire block. It is said that the spirit of an old German widow whose husband died in the house still sits at the window, looking out toward 24th Street.

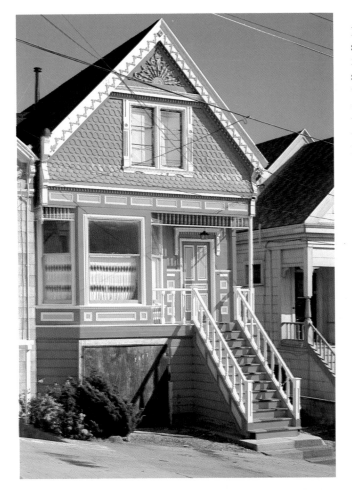

(*Left*). 1007 Castro. 1896. Queen Anne row house. 1976. Donald McCunn, the owner, has used a table saw with a shaping head and lathe to re-create the woodwork decorations in Victorian motifs. He says that San Francisco itself had inspired the colors he chose. Friends felt that an all-white house would allow the "rickrack" to stand out on its own but it didn't. Now the yellow wheat, in the sunburst design at the top of the gable, really pops out of the blue background—the people on the street can enjoy it more. (The garage door has since been painted.)

(*Below*). 727–29 and 731–33 Castro. 1898. Stick/Eastlake. 1975–76. Tony Canaletich and Bob Buckter & Friends color designed the homes shown here. They were built as part of a group of three by Fernando Nelson who was known for his exact duplication in the construction of homes. Nelson's trademark is the cut-out circle or donut pattern found in the doorway panels and in the decorative strips framing windows and doorway.

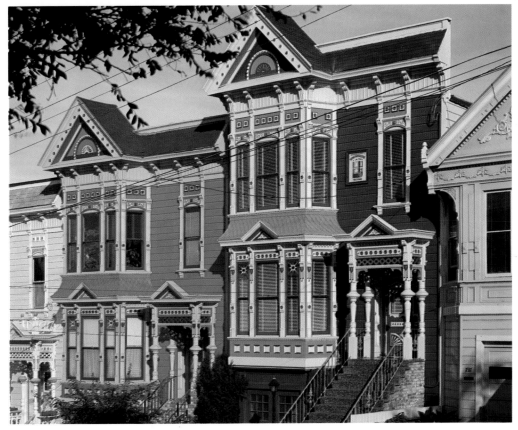

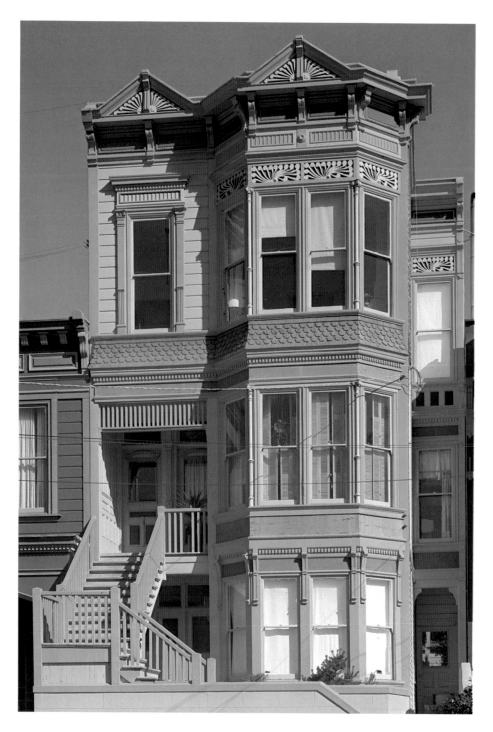

(*Left*). 525–29 Sanchez. 1893. Italianate with Stick/Eastlake influence. 1974. Blissful Painting. The present owner thinks that his house—which looks to him like a Russian Easter egg—is the prettiest house on the street.

(*Opposite, above*). 3733 21st Street. 1885. Italianate. 1973. The owners moved into this house twenty-three years ago and have painted it yellow four times. For this incarnation, they used a white undercoat and a cheerful, clean "jonquil yellow" by Kelly Moore, which has stood up remarkably well. The lush green foliage of this queenly yet diminutive gem has long since wedded the warm yellow house above it, creating a delightful harmonious contrast.

(*Opposite, below left*). 901 Sanchez. 1899. Stick style. 1975. Anne-Lise Mitchell had never chosen colors to cover this big an area before; she kept mixing and testing until it was finished. She wanted her house to be warm and sunny regardless of the weather—"so when I turned onto the street it would light up and feel good to me, and it still does."

(*Opposite, below right*). 104 Chattanooga. 1892. Stick/Eastlake. 1975. Larry Sexter wanted "something different" for his cottage, once white on brown. He painted it himself and feels that making the exterior of your house beautiful is a way of sharing it with neighbors and passersby.

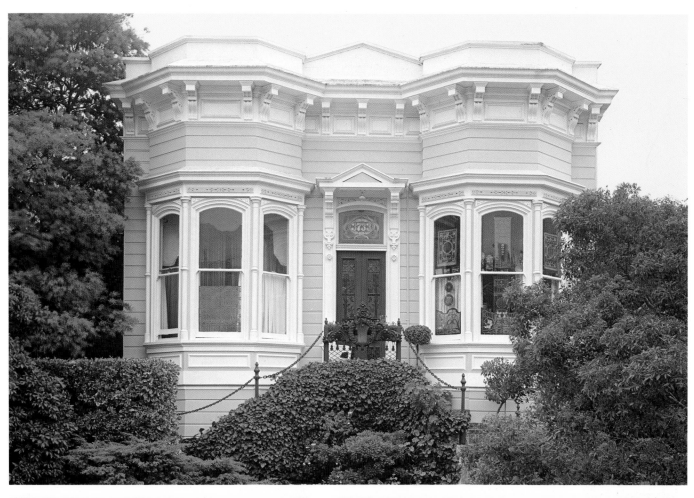

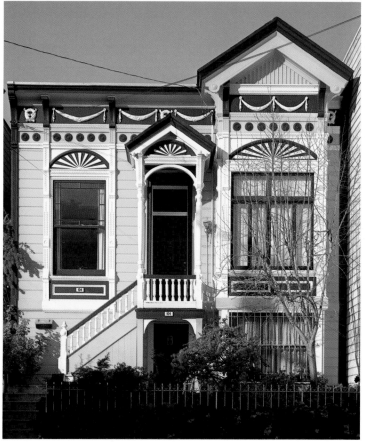

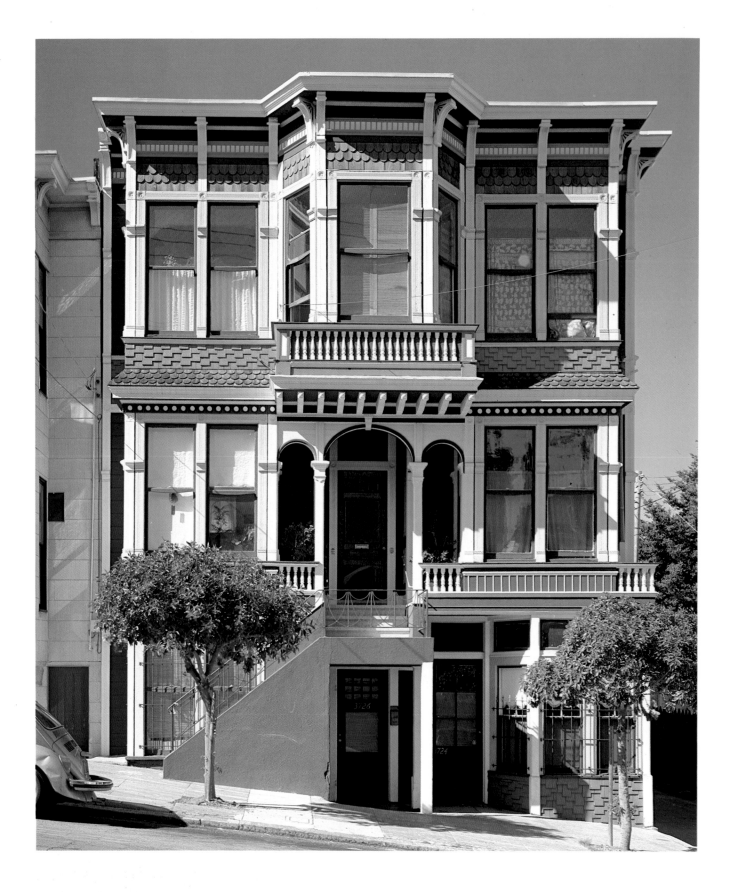

(*Above*). 3724–28 23rd Street. 1890. Italianate. 1975.
The owner designed this house to remind him of New
England. He used seven colors of paint, including three
shades of blue, ranging from dark to light, going from
street to roof.

THE MISSION DISTRICT
and POTRERO HILL

The Mission District

The Mission District sprang up around Mission San Francisco de Asis—the Mission Dolores—not long after it opened in 1776. It is the sunniest, most sheltered area of the Northern Peninsula and has been a self-contained community since its days as Yerba Buena (San Francisco's first official name).

From the 1850s to the 1880s, the Mission was a resort area for San Franciscans, with racetracks, pleasure gardens such The Willows or Woodward's Gardens, and roadhouses tempting fun-seekers out for a Sunday drive. The area became fashionable in the 1880s and 1890s when it became accessible to the main city. (The settlement had been out of reach because of surrounding swamps until a man built a wooden-plank toll road, costing 25¢ per horse and rider, that ran from 3rd and Mission to 16th and Mission.) Mission Street is still the heart of this city within a city. Emigration to this area accelerated after the devastating earthquake and fire of 1906. Today, the Mission is a working-class melting pot, with Chinese and Japanese restaurants next to *taquerias,* and Irish plumbers next to Italian bakeries. But the Mission retains a predominantly Mexican and Latin American character—as befits its Spanish origins.

For identification purposes, we have designated the boundaries of the Mission District as running from Dolores to the James Lick Freeway and from 16th Street to Army.

Potrero Hill

Potrero Hill, named after the Spanish word for "pasture," and located on the other side of the freeway from the Mission, is a mixture of homes and industrial warehouses, all blessed with a wonderful view of the eastern waterfront. For our purposes, the district runs from 19th to 23rd streets and from the James Lick Freeway to Mississippi.

Factory workers moved in during the 1860s when the railroad terminus was relocated to 3rd and Townsend. After 1906, the hill became home for over 3,000 Molokans, a persecuted Russian religious group, as well as for Scots, Slavs, and Midwesterners who now work together to protect their view from encroaching high-rise buildings. Drawn by the area's relatively low rents, a number of artists and craftsmen have moved recently to Potrero Hill.

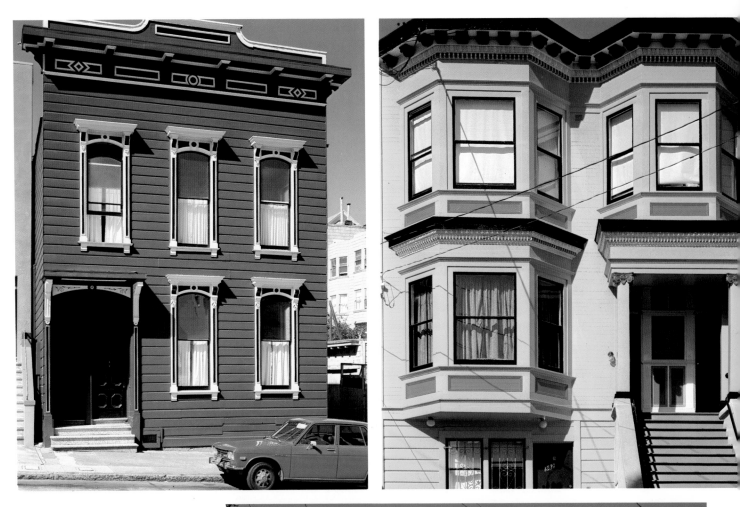

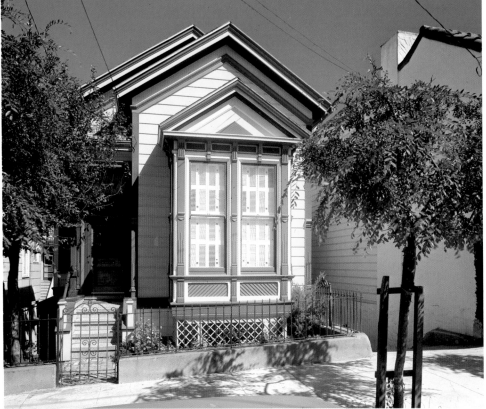

(*Opposite, above left*). 3476–78 22nd Street. 1875. Italianate. 1977. Bob and Kathleen Hohalek wanted to dress up their dull beige home. The jet accents and white trim give extra sparkle to this cardinal red facade.

(*Opposite, above right*). 380–82 Fair Oaks. 1896. Modernized Italianate. 1977. Edward Parker and Juan Garcia just chose colors they liked for this simply ornamented, sun-kissed house. But you can see from the house next door, they also picked colors that harmonize beautifully with those of their neighbors.

(*Opposite, below*). 217 Fair Oaks. 1886. Stick cottage. 1974. Snowflake the Artist worked with the owners with color swatches, with a cut-out mat which permitted the testing of colors in different parts of the house, and with a cardboard model; finally he painted this jaunty little house.

(*Right, above*). 384–86 Fair Oaks. 1896. Queen Anne tower house with Revival influence. 1977. Tony Canaletich for Bob Buckter & Friends. The wife wanted to make the house look feminine; the hubsand wanted it to look masculine. To satisfy both of them, Tony Canaletich used a feminine body color—desert sands—and six precious or superaccent colors, instead of the usual one or two. Gold gilt mediated between the red and the blue in what Tony considered a tough assignment; his solution left his clients very happy.

(*Right, below*). 460–62 Fair Oaks. 1889. Stick. 1978. Robert Logg and Albert Tutino completely restored this once asbestos-shingled home. To get the gingerbread decorations they wanted, they took photographs of details they liked on other houses and then reproduced them themselves. This residence and the house next door made use of a well in the yard for at least ten or fifteen years before the city water was turned on.

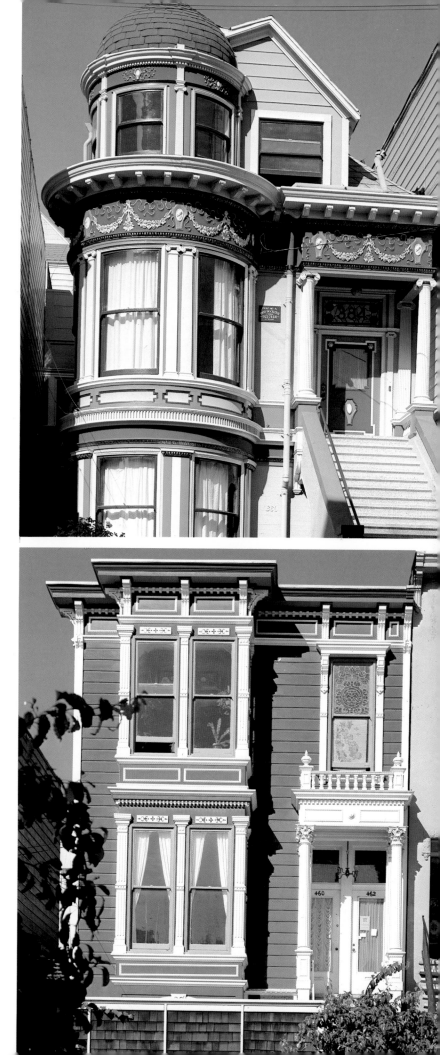

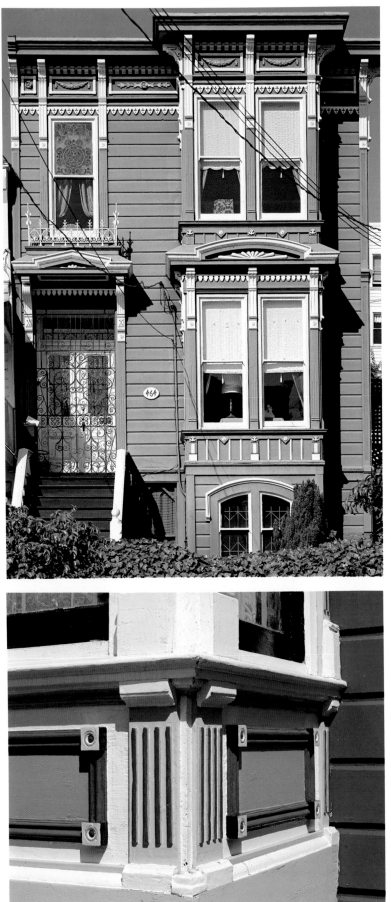

(*Left, above*). 464 Fair Oaks. 1889. Stick. 1973. When Robert Logg and Albert Tutino moved into this house in 1962, it hadn't been painted in sixty years and was a grim gray. The tugboat blue they have used here is marine paint, which resists the elements very well. This is one of the few remaining houses in San Francisco with its original cast-iron fretwork still in place. (During both World Wars iron trim had been removed wholesale to melt down for shells.)

(*Below, left and right*). 1609 Dolores and detail. 1886. Stick/Eastlake. 1976. Mary Lou Vinella, an art teacher, started with tile red as her basic color, then she added the purple used by sign painters and yellow industrial trucking paint. The details, including the sides of the ½″-wide, ¼″-thick strips, were painted with a sable artist's brush.

(*Opposite*). 41–43 29th Street. 1903. Modernized Italianate. 1976. Artist Diana Johnson created this rainbow house with the help of the owner, who also owns the Ameritone paint store next door. A Christmas card with a picture of the house is now inspiring friends in Wisconsin and Indiana to "liven up" their homes.

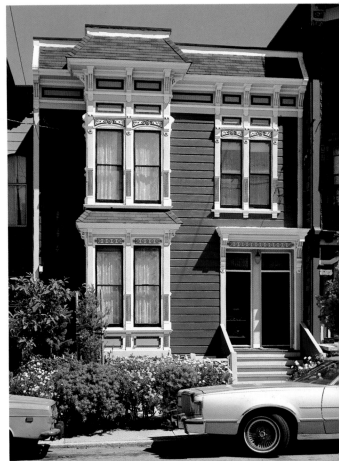

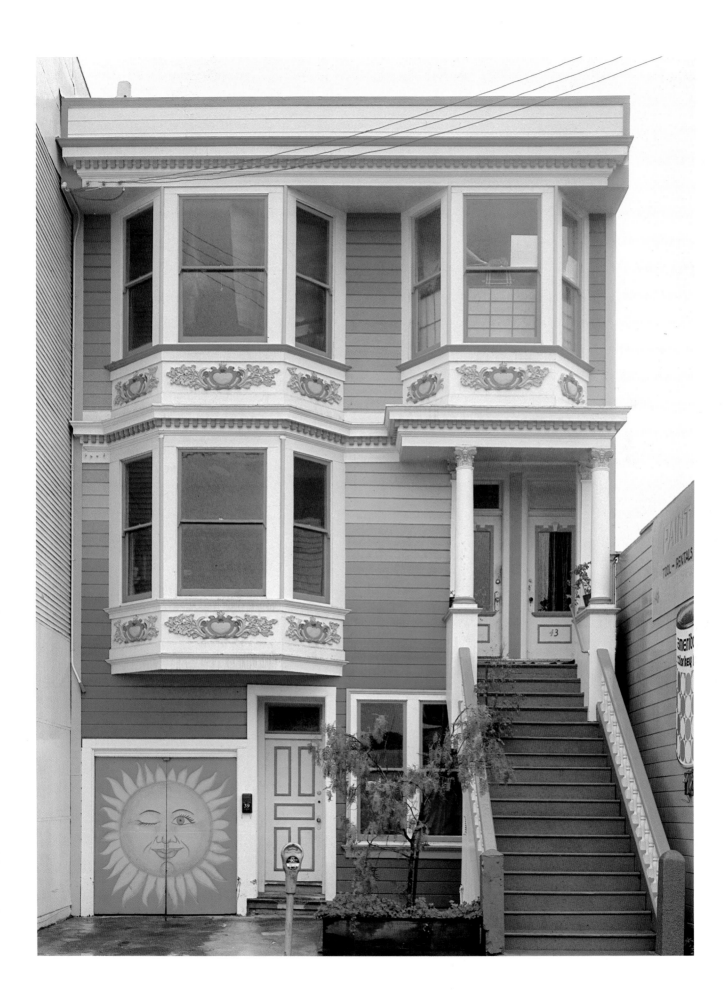

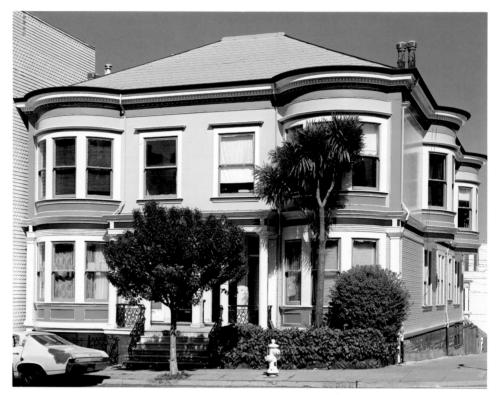

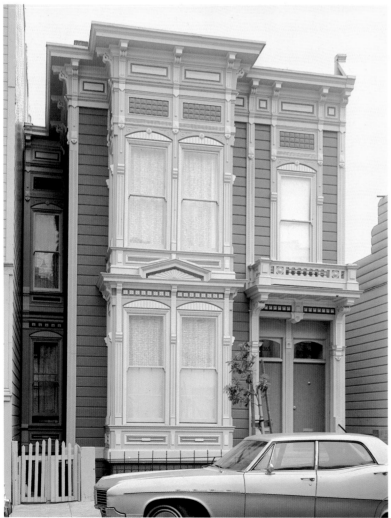

(*Above*). 1143–49 Guerrero, corner of Elizabeth Street. 1904. Italianate with Queen Anne influence. 1977. Butch Kardum created this pristine color design, using the owners' choice of basic blues and browns.

(*Left*). 3365–67 22nd Street. 1882. Stick style. 1975. Butch Kardum chose "something that relates to the Mission" for this forthright building. It once boasted a brothel on the top floor.

(*Opposite*). 964–68 Guerrero. 1890. Stick style double house. 1977. Butch Kardum. The distinguished square bay windows and catalogue millwork ornamentation has now been preserved for the future by the conveyance of Historic Preservation Easements to the Foundation for San Francisco's Architectural Heritage.

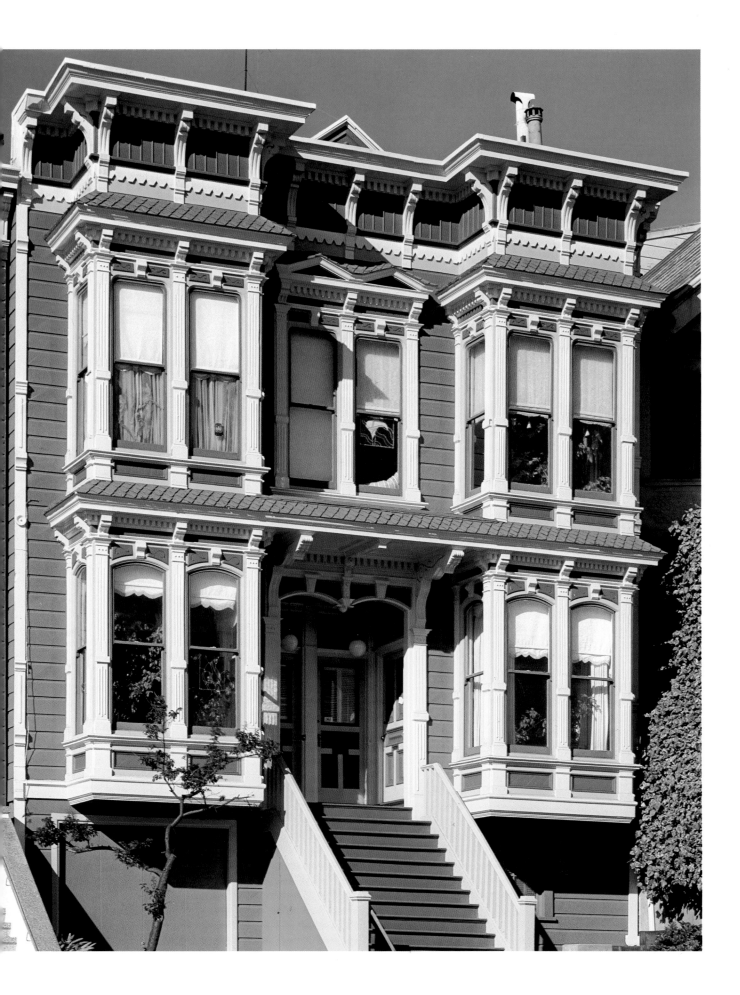

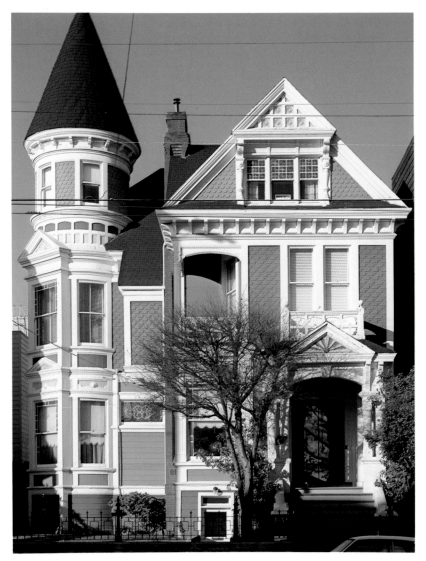

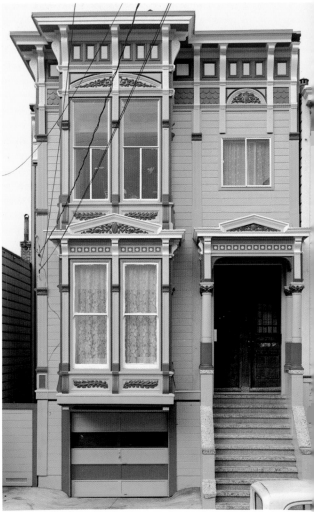

(*Opposite, above*). 1348 South Van Ness Avenue. 1886. Queen Anne tower house with Stick influence. 1973. Color Control. Built for Frank M. Stone by designer Seth Babson, the present owner calls this color design "a tortinière"—a felicitous combination of elements creating a new entity. (See page 15.)

(*Opposite, below*). 1070–72 Shotwell. 1892. Stick/Eastlake. 1977. A friendly man with an Italian accent, Frank Bruno conceived this eye-popping surprise on a side street, creating a controlled explosion of such vibrant colors that they threaten to burst out of the building's narrow confines.

(*Right*). 3152 24th Street. 1899. Italianate. 1977. Butch Kardum designed this raspberry/caramel confection, using the owner's choice of the main color.

(*Below*). 1016–18 B Shotwell. 1902. Stick style. 1975. The owner worked with Butch Kardum's cousin on the color design for this formidable facade.

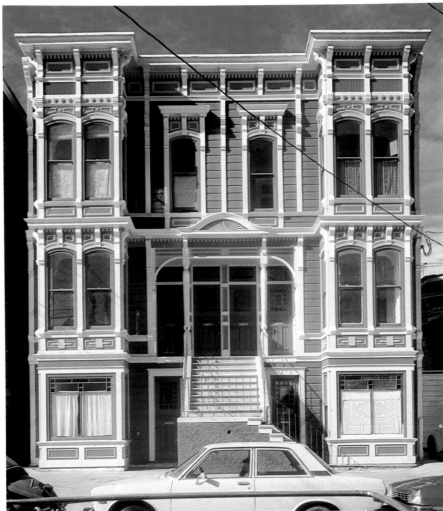

73

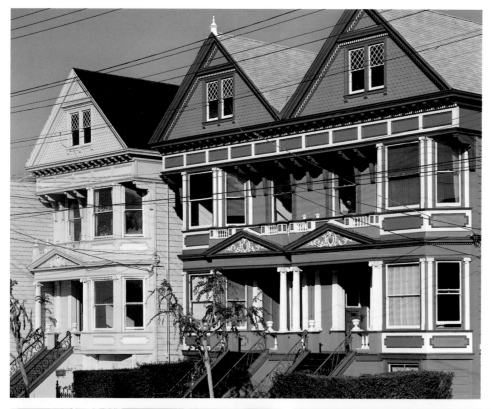

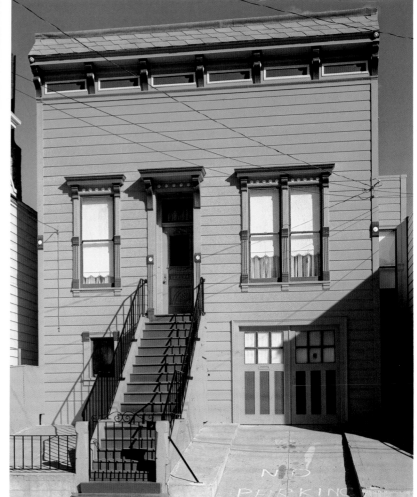

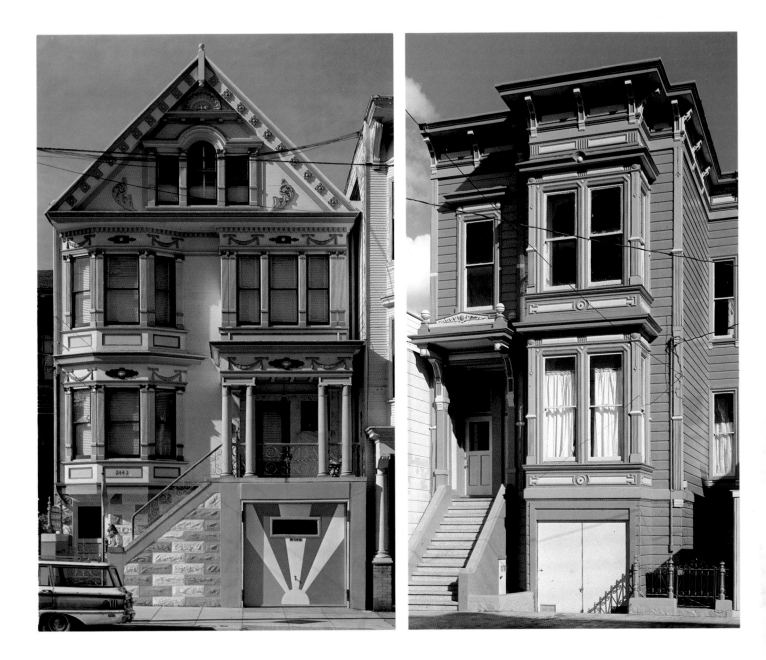

(*Opposite, above*). 2853–63 Folsom. This stand of Queen Anne row houses was built in 1894.

(*Opposite, below left*). 1165–67 Treat Avenue. 1895. Stick style. 1977. Karen Silverman designed the colors to highlight the millwork her husband made to help restore the facade.

(*Opposite, below right*). 871 Treat Avenue. 1897. Italianate. 1977. The owner chose to bedeck her simple cottage with sunny colors.

(*Above, left*). 2442 Folsom. 1909. Queen Anne row house. 1975. The neighborhood children call this the "fruit salad" house. We call it a "wedding cake" house. The owner and a friend went to the store, got the colors they liked, and blended twelve colors as they went along.

(*Above, right*). 385–89 Shotwell. 1885. Stick/Eastlake. 1977. Roberto Herrera. In the best Mission tradition, 385–89 Shotwell glows with a different yet seductive approach to color, brimming with vitality that is effectively muted by the trim.

(*Below*). 1621–23 Folsom. 1908. Queen Anne row house. 1975. Lora Vigné, owner and designer of Noir Enamelcraft, designed this house to reflect her enamel work. That 6-foot by 8-foot plaque on the second floor is enamel! Ms. Vigné, known for her family of ocelots, has an adjoining yellow house and an orange one, used as a workshop, centered around a huge backyard.

(*Opposite, above left*). 573 South Van Ness Avenue. 1878. Queen Anne tower house. 1976. The part-owners of this wonderful tower house, who have restored several buildings, replaced plaster castings of scones and the cupids around the bay windows. Then Bobus Smithton picked up cool, tasteful, yet contrasting, tones from an office in the building painted with similar colors. It certainly makes an interesting juxtaposition with the garage next door!

(*Opposite, above right*). 1334 Utah. 1895. Stick/Eastlake. 1976. William Mendoza and friends chose the colors for his house (the base color is dark Wedgwood). They talked to an artist friend who drew a diagram of the house and did the color design, and then they got up on scaffolding and painted it themselves. Some of the gingerbread on this previously white with black trim home was so fine the crew had to use artists' brushes to get into the nooks and crannies.

(*Opposite, below left*). 1165 Kansas. 1906. Queen Anne row house. 1976. Artist Lynn Howe chose this eye-catching combination to decorate her gable.

(*Opposite, below right*). 1071–75 Kansas. 1903. Italianate with slanted bays. 1973. Moved to its present site, this is one of the houses that was saved from demolition when the freeway was built in the 1940s. Doris and Manuel Gonzales were inspired to paint a rainbow by the shape of the multilevel arch. And although they later thought about painting it over, their neighbors' praise prompted them to keep it.

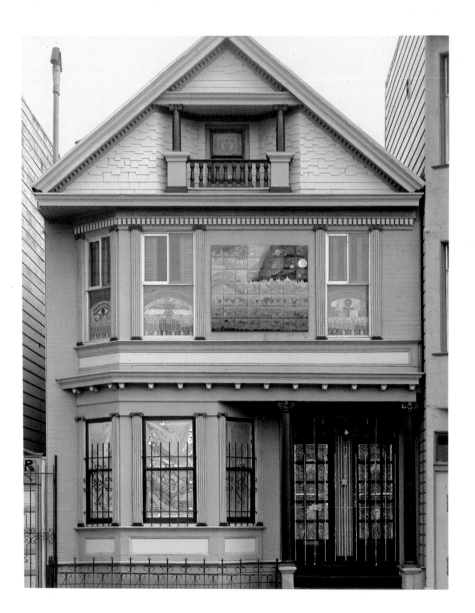

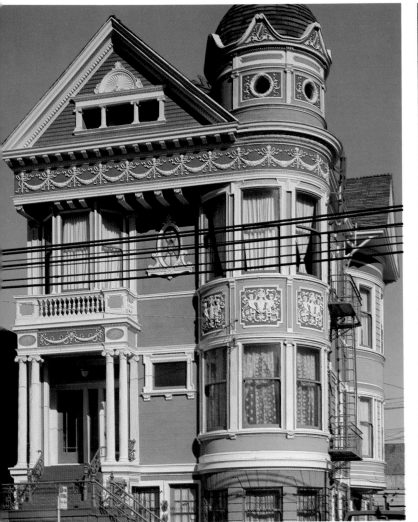

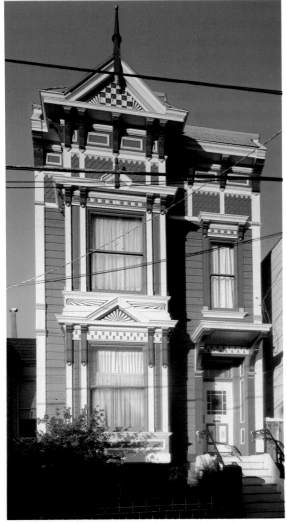

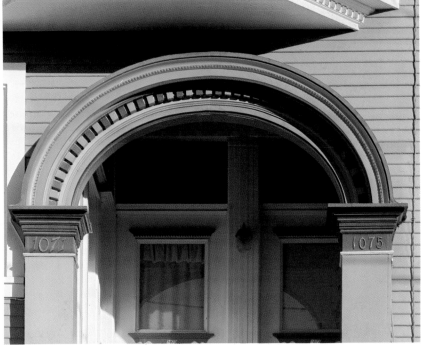

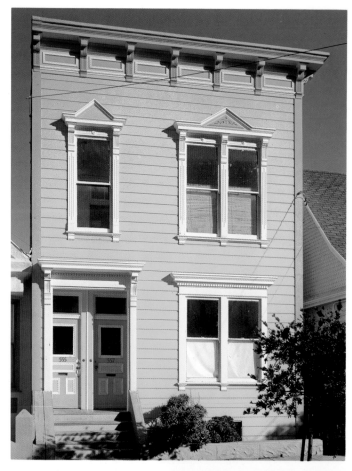

(*Left*). 555–57 Connecticut. 1889. Italianate. 1976. Aileen and Peter Hoagland gilded their house together, after she persuaded him not to paint it gray.

(*Below*). 430 Mississippi. 1889. Italianate. 1977. Designer Peter Goosev drove around the city with the owner seeking inspiration. They found it at 54–56 Lower Terrace (see page 56) and used the same color combination. They are now glad that their colors turned out lighter than the house it was patterned after.

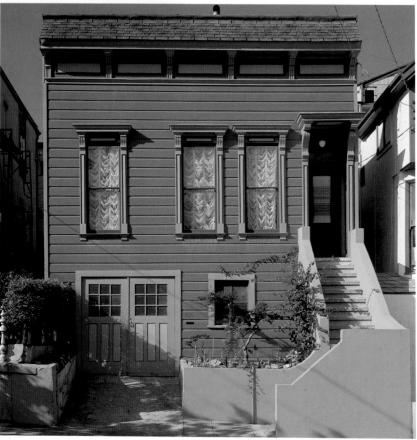

Notes on the Photographs

Because photographs for *Painted Ladies* were to be made in color, and because a "print" size approximating the published size of the plates was required, certain changes from my usual way of working with camera equipment, film materials, and processing were automatic.

The rear of my 8 x 10 Ansco view camera, to which I have become accustomed through many years of work, was replaced with a 4 x 5 back. The smaller holders were pulled off the top shelf, cleaned thoroughly with forced air (for each loading), and placed in the working film case.

Eastman's Professional Ektachrome was chosen as the most amenable color material. It was processed by a professional laboratory with consistently fine results in E-6. Tungsten film, with its called-for accompaniment of 85B filtration, was used throughout. In my experience, the middle-range color film responds more flexibly to variations in subject and illumination color than does Daylight Ektachrome. Plates were made directly from the transparencies.

Almost all photographs were also made through the warming effect of an added 2A filter. Even San Francisco's clearest bright days are often haze-ridden—to color films. I personally like the counter-action of the 2A rather than the slighter effect of the 1A. Neither alters colors enough to make an observer conscious of change. To this photographer, the 2A makes warmly colored houses appear right; blue or green houses seem to absorb only minute tonal differences.

A series of smaller lenses than are usually used were put to work on the big camera. For the widest coverage in still-narrow streets, Schneider Super-Angulons of 90 and 121mm worked admirably. A Goerz (American-made) Dagor of 6 inches served well where I could draw back enough from the subject.

A Schneider Symar of 8¼ inches and an old Zeiss Apo-Tessar of 10 inches covered many complete facades for me from across the street or down the block. The 10-inch Apo-Tessar and another of 15 inches were used on all the small details. All lenses are coated, so that seeing into the colors for full absorption was never considered a problem.

The 8 x 10 view camera with these lenses fitted to its front seemed to provide me with more flexibility in alignment—probably because my hands and eyes are so used to this camera—than any 4 x 5 view camera would have.

This is in no way meant to promote the use of large view cameras. It has been exciting to see the work of many younger photographers who with their own highly developed sense of competence use smaller cameras of varying sizes with more spontaneity in their results than I happen to find satisfying. My eyes—is there any piece of equipment more important?—are accustomed to looking for, explaining, understanding, revealing a forthright rectangularity in architectural design. I love it; I find it strong, explicit, and edifying. But through others' eyes, a more casual, sometimes fleeting but still penetrating, treatment of architecture can be preferable. I see no reason to circumscribe any validity in photographs, when it is called for and when it is produced with skill.

I like to think that the means in photography must be commensurate with the way a photographer thinks, feels, and responds to photographable material. When photographers free their own individual ways of seeing and develop their own insights, we may all choose more wisely the means of transmitting photographs.

MORLEY BAER

Garrapata, May 1978

Authors' Biographies

For some thirty years MORLEY BAER has been involved with photographing the natural scene and the buildings of the West Coast. His photographs of the country in which he takes a particular delight in living are shown in black-and-white prints in museums and commercial galleries, and they are increasingly sought out by collectors who regard straight photography as an individually expressive force. Work for architects, and the editors who feature their designs, is seen regularly in national shelter and architectural magazines.

Photographs of many of the same Victorians (unpainted!) featured in *Painted Ladies* were first shown in an earlier book on San Francisco's architectural heritage called *Here Today* (1968). *Adobes in the Sun* (1972) looked carefully and with strong sympathy at the early, simple shelters of historic Monterey. Another intensive survey of those historic and contemporary houses that define San Francisco's unique architectural style was published as *Bay Area Houses* (1976).

As a photographer Morley Baer continues to be vitally concerned with the natural and man-made forms that he knows must be maintained as essential to California's rich and varied character.

New Yorkers ELIZABETH POMADA and MICHAEL LARSEN worked in publishing before emigrating to San Francisco where, in 1972, they started their literary agency. Together they created *California Publicity Outlets* (1972), rechristened *Metro California Media* in 1978 and published annually, and *Places to Go with Children in Northern California* (1973). In addition to writing and agenting books, Elizabeth Pomada also writes occasional articles and book reviews.

Bibliography

BOOKS

Baird, Joseph A. *Time's Wondrous Changes: San Francisco Architecture, 1776–1915.* San Francisco: California Historical Society, 1962.

Beebe, Lucius, and Clegg, Charles. *San Francisco's Golden Era.* Berkeley: Howell-North Books, 1960.

Bruce, Curt, and Aidala, Thomas. *The Great Houses of San Francisco.* New York: Knopf, 1974.

Bullock, Orin M. *The Restoration Manual.* Norwalk, Conn.: Silvermine Publishers, 1966.

Dornsif, Samuel J., ed. *Exterior Decoration—Victorian Colors for Victorian Houses.* Athenaeum Library of 19th Century America. Philadelphia: Athenaeum, 1976.

Gebhard, David, et al. *A Guide to Architecture in San Francisco and Northern California.* Salt Lake City: Peregrine-Smith, Inc., 1973.

Junior League of San Francisco. *Here Today.* Photographs by Morley Baer. San Francisco: Chronicle Books, 1968.

Kirker, Harold. *California's Architectural Frontier Style and Tradition in the Nineteenth Century.* Santa Barbara, Cal.: Peregrine-Smith, 1973.

McCoy, Esther. *Five California Architects.* New York: Praeger, 1975.

Muerch, Joseph. *San Francisco's Bay Cities.* New York, 1947.

Newsom, J. C. *Picturesque California Houses.* Vols. I–III. San Francisco. 1880–90.

Olwell, Carol, and Waldhorn, Judith. *A Gift to the Street.* San Francisco: Antelope Island Press, 1976.

Pelton, John C., Jr. *Cheap Dwellings.* San Francisco, 1882.

Vail, Wesley D. *Victorians: An Account of Domestic Architecture in Victorian San Francisco 1870–1890.* San Francisco, 1964.

Victorian Alliance. *Pocket Guide to San Francisco's Landmarks.* San Francisco, 1976.

Waldhorn, Judith. *Historic Preservation in San Francisco's Inner Mission* and *Take a Walk Through Mission History.* Washington, D.C.: Department of Housing and Urban Development, 1973.

PERIODICALS

Bay Views, December, 1977.

California Architects and Builders News, May, 1882; April, 1885; September, 1889; March, 1891.

California Living, January 18, 1976.

Communication Arts, January/February, 1975.

Overland Monthly, December, 1900.

Scientific American (Architects and Builders Edition), 1886, 1887, 1891.